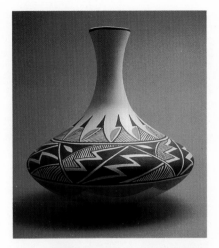

Artistry
IN CLAY

"We have always made black pottery here," said María Martin͟͟͟ ͟ ͟ grandmother made it, and taught her daughters. My mother died and my a͟ ͟ ͟ ͟aught me. I have no daughters," her face saddened, for the lack of daughters is a break in the line in the pueblo matriarchal system, "but I am teaching my daughters-in-law and my nieces."

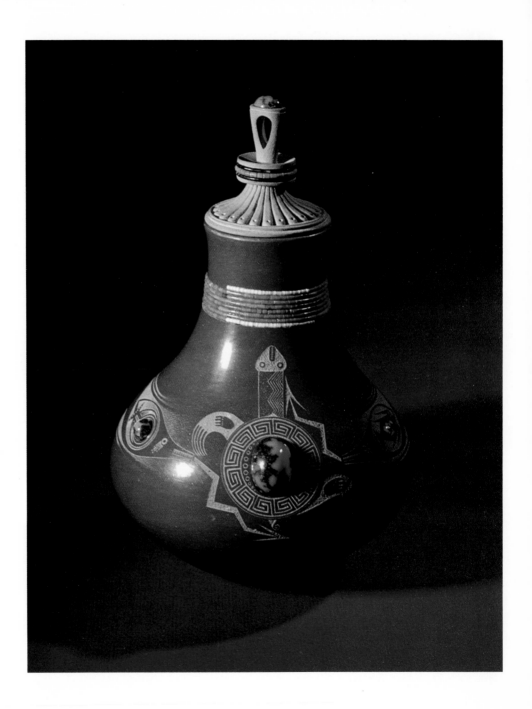

Artistry in CLAY

Contemporary Pottery
of the Southwest

by **DON DEDERA**
Foreword by **JERRY JACKA**

NORTHLAND PRESS
FLAGSTAFF, ARIZONA

For Annabeth

COVER: Pottery by Grace Medicine Flower, courtesy
Galeria Capistrano, San Juan Capistrano, California.
Photograph © 1985 by Jerry Jacka

FRONTISPIECE: Pottery by Tony Da, from *María* © 1979
by Richard Spivey (Northland Press, Flagstaff, AZ).
Photograph by Jerry Jacka

The photographs on pages 31, 33, 59, and 60 are from *Modern Pueblo Pottery,* 1880–1960 © 1977 by Frances H. Harlow (Northland Press, Flagstaff, AZ); those on pages 52 (Jerry Jacka, photographer) and 62, 63, 66 (Bob Hanson, New York City, photographer) are from *Generations in Clay* © 1980 by Alfred E. Dittert Jr. and Fred Plog (Northland Press, Flagstaff, AZ). The photographs on pages 10, 12, 14–18, 20, 22, 24, 25, 26 (bottom), 27, 28, 32, 34, 37, 49, 58, 61, 64 (top), 70, 71, and 77 are copyrighted by Jerry Jacka and are used with his permission. All other photographs are the property of the author.

For 'tis not verse, and 'tis not prose,
But earthenware alone
It is that ultimately shows
What men have thought and done.

ALFRED DENIS GODLEY

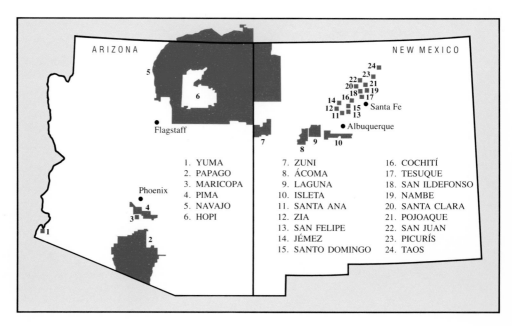

ARIZONA NEW MEXICO

1. YUMA	7. ZUNI	16. COCHITÍ
2. PAPAGO	8. ÁCOMA	17. TESUQUE
3. MARICOPA	9. LAGUNA	18. SAN ILDEFONSO
4. PIMA	10. ISLETA	19. NAMBE
5. NAVAJO	11. SANTA ANA	20. SANTA CLARA
6. HOPI	12. ZIA	21. POJOAQUE
	13. SAN FELIPE	22. SAN JUAN
	14. JÉMEZ	23. PICURÍS
	15. SANTO DOMINGO	24. TAOS

Map of the primary pottery-making regions of Arizona and New Mexico.

Contents

Foreword . ix

Introduction . 1

1 Ancient Ways of Modern Pottery 5

2 Pottery: Humanity's Rear-View Window 11

3 Pottery and Potters of Arizona 23

4 Pottery and Potters of New Mexico 35

5 Notes on Finding and Keeping a Worthwhile Pot 78

Acknowledgements 81

Selected Readings 82

Index . 83

Foreword

"THEY ARE WROUGHT of the world's humblest substance, earth itself . . . are shaped and tinted by the tools and shades of nature . . . and finally are fired in a homely kiln of dried animal dung. When done, they are merely called pots."

So wrote my good friend, Don Dedera, in his wonderfully but simply stated, informative book on southwestern Indian pottery. He goes on to explain why pots are not merely pots, but a current and vital art form that has its roots in New World culture predating the time of Christ.

Although this book is not intended to be a thorough, scholarly treatise on the prehistoric, historic, and contemporary ceramics of the first Americans of Arizona and New Mexico, it does present a useful introduction to southwestern pottery—and more.

Beyond a discussion of an art, it tells also of the ancient cultures of the American Four Corners states—Utah, Colorado, New Mexico, and Arizona—and the northern states of neighboring Mexico, those bands who hunted and farmed the lands of the great Southwest at a time when the so-called "higher civilizations" were flowering along the Mediterranean Sea.

In some detail, the narrative explains how a ceramic vessel is made today, and how the foundations of this technology derive from the beautiful wares fashioned by artisans centuries ago. Through words and photographs, the book celebrates many types of southwestern pottery of the past and present. Included also are names and neighborhoods of talented, contemporary personalities.

My own deep appreciation of Indian pottery began as a boyhood curiosity. Broken pieces of fired clay littered the surface of part of my parents' ranch north of Phoenix, Arizona. The sherds—both drab and colorful—fascinated me, and I felt compelled to learn of their origins. That led me to friendships with numerous potters still active in nearby Indian communities. I put together a then-inexpensive collection. I wanted pictures of them, and they became the subjects of my first photographs. Eventually, my hobby grew to a profession. (Today, without boasting, my photographic interpretations have appeared on the front cover of *National Geographic* and have filled entire issues of *Arizona Highways Magazine*.) I sincerely pay homage to the primary artists who have shared their works with me, taken me into their homes, and extended lasting friendships.

Yet with all of that experience, I found that I learned things from this book, and was reminded of insights all but forgotten. My spark of curiosity was rekindled, and once again, I wanted to know more.

That's what this book is all about. It provides an excellent primer for beginning pottery collectors, for new visitors who may yearn for an authentic souvenir from the Southwest, or for armchair travelers who cherish art of all kinds, of all lands, of all times.

For the subject of this book is exactly that—a unique form of art. Unique also are the artists who create it.

JERRY JACKA

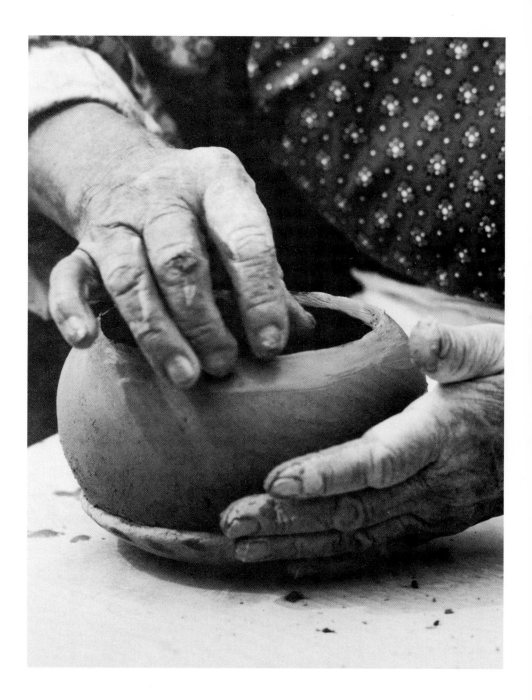

Introduction

"NOBODY, BUT NOBODY, KNOWS IT ALL." So said Harry Glenon, a good friend, when last I visited with him in 1968. His store was strangely bare and chill, like a bachelor's refrigerator. In the rear, Harry was bravely trying to keep the little light burning.

He glowed in a pastel shirt, a necktie wrought of sheet silver, a tooled belt with jeweled buckle, and fancy white cowboy boots. He sat rocking and studying the body language of the few customers and dealers. For thirty-five years he and his wife Ida had operated the Indian School Trading Post across the street from the Phoenix namesake school. Now Ida was dead. Harry couldn't bear to carry on the business she had founded. In a few months, he would be gone. Forever.

"I'm going visiting," Harry said. "Sad, how it worked out. Since 1933, right through the Depression and the Second World War, we took only one short vacation, thinking we would someday have enough to quit and go visiting. But she passed away before we could quit."

Harry Glenon had an expert, even mystical, perception of American Indians and their art. He claimed knowledge of 2,300 specific tribes and bands. He could recognize the source of American flannel raveled and respun into a Navajo textile; could name the type of pitch daubed onto a Nez Perce canteen; by its look, could name the maker of a Hopi bracelet.

Harry was convinced that a form of Gresham's Law doomed genuine Indian arts and crafts. "Counterfeit junk," grumped Harry. "Hong Kong beadwork. Stamped jewelry. Manufactured rugs. Pottery from a wheel. Plaster of paris kachina dolls. Commercial souvenirs. It's flooding the market . . . driving out the good stuff. The Maricopa women used to change buses twice in order to bring their pottery into town, and out to our store; we'd buy it for resale, and deliver the Indians back home in our car. But the Maricopas don't come to town anymore. There is no Maricopa pottery. The Pimas used to weave baskets on the sidewalks downtown. No more. They aren't weaving, and their children aren't learning."

Harry's soliloquy provoked an exchange of opinion between a customer and a dealer. Customer (reproachfully): "It's a terrible shame that the Indians are turning their backs on their heritage, their own traditions!" Dealer (defensively): "Why shouldn't they quit making artifacts by hand? A Pima woman might have to work for a month to produce a basket she can sell for twenty dollars. Who can feed a family these days on twenty dollars a month? Maybe if you'd be willing to pay three hundred dollars for a basket, there would be plenty of Pima weavers." Customer: "I didn't mean all the Pimas should make baskets. Just some of them." Dealer: "They would, if you were willing to pay a fair price!"

Glenon interrupted. "Gentlemen, you are both just wasting your breath. If there's one thing I know for certain, the good stuff is nearly all gone, and it will never come back, no matter what we do or say." A few weeks later, the door closed and the light winked out, and Harry went visiting. Alone.

Events proved Harry Glenon wrong. Not entirely, of course. But as did many lifelong traders, he lost faith on the very eve of a renaissance of native American craft arts. Across the decade of the 1970s and into the '80s, greater America and the world took unprecedented

interest in Indian artistry. Patrons in large numbers around the globe demonstrated a willingness to pay ten times twenty dollars for a finely crafted Pima basket and ten times more for a necklace of turquoise and gold.

They are wrought of the world's humblest substance, earth itself . . . are shaped and tinted by the tools and shades of nature . . . and finally, are fired in a homely kiln of dried animal dung. When done, they are merely called pots.

Yet the traditional creations of the master potters of the American Southwest win increasing acclaim as works of exquisite art. Certain potters today enjoy artistic reputations so lofty as to require no more than a single name for recognition: Rose, María, Lucy, Dora, Margaret, Luther, Santana, Camilio, Tse-pe. Tony could only be Tony Da, whose fees ($3,000 for a ceramic turtle) rival those of contemporary geniuses in paint, bronze, and marble.

Although belated, this widening recognition promises to revive, sustain, and expand a native American art form that in many ways was thought to be doomed. Potters of sixteen to eighteen New Mexico pueblos and at least three Arizona reservations keep faith with a cultural heritage that has been evolving for more than two millennia.

Some products of modern potters are little changed from the 1500s when the conquistadores of Spain invaded their windswept mesas and lush river valleys. Other pots bear designs borrowed from ancient, excavated sherds. And still other contemporary pottery conveys fresh frontiers of expression. Gifted, young, imaginative potters become overnight celebrities whose mystique is multiplied, as with other major artists, by controversy and intrigue.

Are the *avant-garde* miniatures of Joseph Lonewolf legitimately related to the lore of his Santa Clara pueblo? And if so, how does he contrive colors that elude his colleagues? "Does Mr. Heinz tell his pickle recipe?" grins Joseph. "This one is a secret family recipe, too. But it is not new as people say it is. Such colors were achieved in prehistoric times by my ancestors. Just visit a museum and see the pots from archaeological digs, and you'll see the same colors I'm getting."

Nor is prideful pot-making limited to the new generation. Elderly Virginia Duran, in her modest home in Picurís pueblo, sells her twenty-five dollar bean pot to a tourist and guarantees, "We of Picurís make the best bean pot. Ah, those people of Taos! We taught them everything they know!"

Thus, the pottery of native southwestern peoples must not be confused with factory-formed, glazed curios, or carnival kewpies. Into the best of Indian ceramics go hours of talented effort and inherited ability. Changing handcraft is mated with human creativity, and the direction is away from utility and toward artistry. Pueblo homemakers still serve their time-honored favorites—squashblossom stew, blue corn meal with wild celery, corn soup, sagebrush bread, piñon nut cake—but on commercial china or plastic or paper. Their precious pottery remains on the shelf or is displayed for sale on a table out front.

These days, purists lament the combinations of unnatural poster paints and exotic

shapes (a duck-billed platypus!) in tourist souvenirs. But even the chartreuse-and-lavendar trinkets carry authentic native designs. And to accentuate the positive, the bulk of current production honors the disciplines of the past:

• The pottery is shaped by hand, not thrown on a wheel, which was unknown in the pre-Columbian Western Hemisphere. Clays are from local deposits.

• If shiny, the polish is not from a simple silicon glaze, but rather from careful burnishing by hand.

• Wares, in the main, are painted with vegetable and mineral colors before firing, and old styles survive in black on white, buff, or cream, with zones of red.

• While perhaps smaller, the forms are akin to functional pueblo relics: shallow bowl, wide-mouth pot, tall water jar.

• The pottery is not fired in a kiln, but in a simple oven assembled on bare ground for one burn.

Never was it, nor is it now, the easiest way to make a living. The story of Rose Gonzales (crafting one of her award-winning bowls, page 4) parallels the record of southwestern pottery of this century.

Born of San Juan pueblo parents, she married a San Ildefonsan and moved to his home. A potter from girlhood, she augmented the family income by making blackware in her spare time. But when her husband died, leaving her with four children, she was obliged to work fulltime as a domestic at nearby Los Alamos, New Mexico. When her children were grown, she returned to her art, earning both critical praise and—thanks to better prices—a decent income. Her wit, expertise, and cooperative nature have taken her to California, Texas, and Washington, D.C.'s Smithsonian Institution to demonstrate her technique.

The generations following Rose Gonzales are potters. Those active today are studies in acculturation. They intermarry among tribes and across racial lines. They may speak Keresan at home, Spanish with neighbors, and excellent English acquired in public schools and graduate art institutes. Rose's son displays his name on the personalized license plate of his late-model car, and his idea of a good time is a weekend in Las Vegas, Nevada. Rose's grandchildren have, all their lives, absorbed the great American equilizer: television by the hour.

This succession represents a blurred and unpredictable situation that raises the question: are they Indians who happen to be artists, or are the newer generations artists who happen to be Indians? For certain, their art is exceptional, a commingling of talents that wins blue ribbons at art shows. Is their style that of Zia pueblo, or San Ildefonso, or (through Rose's influence) something of San Juan? And is that so crucial anymore?

As encouraged by centers such as the Institute of American Indian Art at Santa Fe, New Mexico, the younger ranks of Indian artists blend the best of the past with modern media. So long as they keep their hands in the clay, an art characteristically Indian will flourish.

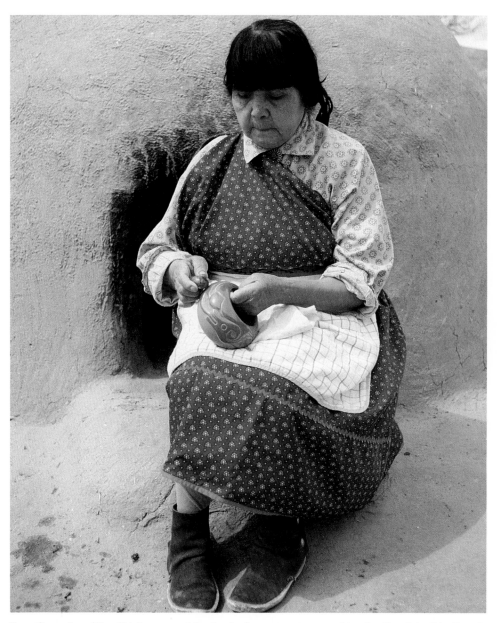

Rose Gonzales of San Ildefonso, matriarch of a famous pottery-making family of the Rio Grande Valley of New Mexico.

Ancient Ways of Modern Pottery

THE MAKING OF contemporary southwestern Indian pottery requires dedication and loyalty to old ways.

Specific sites of uniform clay—not crumbly adobe—are highly prized. If necessary, a potter will travel many miles to the better deposits, some of which are kept secret. The potter, generally a woman, may go in a pickup truck and dig with a steel pickaxe, but as her mother before her, she will speak to the Earth and ask permission to take a gift from a respected Being. In earlier times, mining of clay occasioned a ceremony; even today, Zuni potters join in a secret ritual of thanksgiving at favored digging pits.

Once at home, the potter culls stones, pounds lumps, and grinds dry clay on a stone *metate* or mortar. Further refinement by winnowing and sifting may follow. Clays of varying consistencies may be blended. In central and southern areas of the Southwest, clays tend to turn brown or orange during firing; in the north, clays fire white or gray. Processes of preparation are far more important than they might seem to the uninitiated.

To prevent cracking, some clays are invested with a temper of sand, volcanic ash, or pulverized potsherds; temper allows a more even distribution of heat during firing. Other clays, naturally abundant in grit and mica, require no additional temper. Not just a matter of volumetric measurement, the proportion of temper to clay is determined by touch and experience. A few days before use, the clay mixture is moistened and set aside to cure.

A pot begins as a round patty formed into a base with a rounded ceramic dish or a cured plaque of basketry. Although a potter's wheel was never used in pre-Columbian America, and is spurned by today's traditional potters, this base plate or basket serves somewhat the same function as a wheel. "To make the pot nice and round and all the curves equal, you have to keep turning it," says Evelyn Cheromiah, premier potter of Laguna pueblo.

Two basic techniques prevail in forming the body of the piece: *Paddle and anvil,* in which the walls of the pot are built up vertically in a rough fashion. A rounded object, such as a river stone, is held against the inside wall, and shape is induced by the pounding of a paddle of wood or stone. Walls are smoothed by a piece of gourd, shell, or corncob. *Coil and scrape,* in which pottery walls rise in sausagelike coils. Ever-moist fingers pinch the coils together and press the interior walls. Dried sections of hard-skinned gourds, which are never lent to other potters, are used to true the curved sides. (It is possible to follow with one's own fingertips the marks made by an ancient potter's hand.)

When formed, the pot is set aside in the shade to dry. In a day or so, it is scraped again,

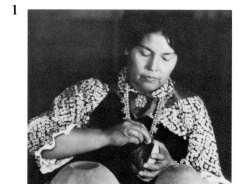

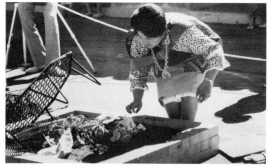

(1) In a demonstration at San Diego's Museum of Man, Evelyn Cheromiah fashions a variety of Laguna pottery. (2) In an early step in firing her wares, Mrs. Cheromiah heats a layer of old, broken pottery within a bed of coals. (3) Then, the new, "green" pottery is arranged on a metal rack; an oven of dried dung is built to cover the unfired pottery.

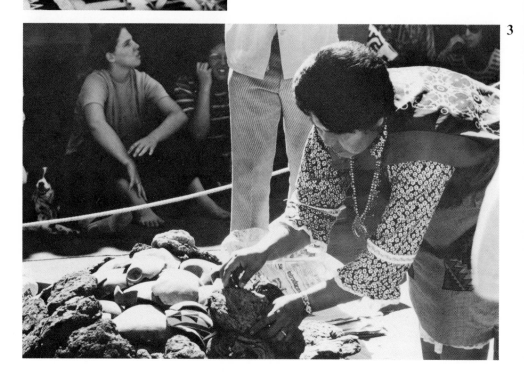

4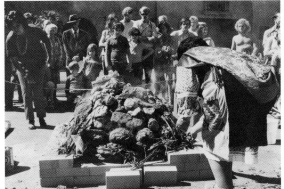

5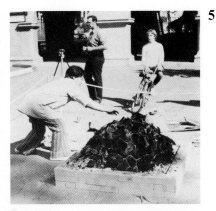

6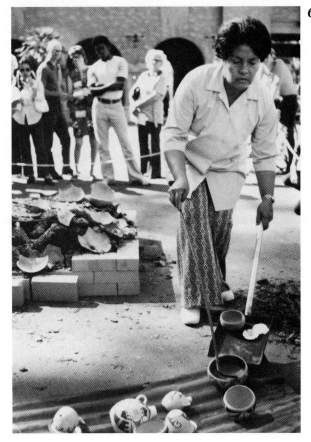

(4) When the oven is complete, kindling of tree bark and newspapers is ignited. (5) An hour later, Mrs. Cheromiah's oven continues to burn; here, she adds fuel to maintain an even temperature. (6) The firing completed, Mrs. Ceromiah carefully sets out the finished pottery to cool.

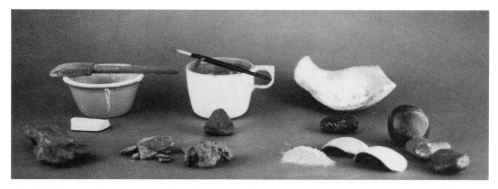

The tools of a Pueblo potter: from left, *minerals and brush for manufacturing and applying slip; organic pigments for painting designs; pieces of gourds and polished stones for shaping and burnishing wares.*

perhaps with a knife, to final form. In some instances the pot is swabbed with a wash of kaolin or bentonite, ranging in color from stark white to muted buff. This wash, called slip, may also be of colored clay ground as finely as flour. A prevalent Rio Grande Valley white slip manifests a natural soapy quality, which aids polishing. Depending upon locale, the slip may be burnished while wet to a silken sheen with gemlike river pebbles chosen for their concave and convex chords. Highly prized agate and chalcedony pebbles are passed down through pottery-making families. Burnishing can take hours and many applications of slip, yet all too often, unknowing tourists assume that the shine is from a simple, painted-on glaze.

Potters compound red, yellow, and brown paint from manganese and iron oxides such as ocher. Other minerals—hematite, limonite, and kaolin clays—lend distinctive hues. Some black shades are derived from plants, notably the tansy mustard, Rocky Mountain beeweed, and mesquite. Beeweed is rendered to cakes, which when used, are ground and mixed with water in a stone mortar.

The paint brush is likely a yucca leaf, frayed by chewing and trimmed. A few potters outline their designs first in pencil, but most lay on their paints freehand, with incredible steadiness and sense of balance.

In several New Mexican pueblos, pottery is incised—cut or pressed with a design as simple as a five-line "bear paw," or as complicated as a "rain serpent" that curls 360° around the piece. Some incised designs may be accentuated with paints or slips, or a variety of colors inherent in the different layers of ceramics. Analysts have concluded, however, that relatively few basic elements go into the most complex designs. An increasing amount of today's pottery is formed in animal and human shapes, as figurines, or as adornments on "effigy vessels."

Clay is not pottery until fired, and firing is the potter's moment of truth. Unless conditions are perfect, pots may emerge cracked or scorched. First, a fire is allowed to burn to coals on a dry, still day. The coals are spread and covered with large pottery sherds. Perhaps an asbestos blanket is added. In the old days, a grate of green limbs and stones would be built over the coals; now the grate is often made of scrap metal and tin cans . . . in one instance, an abandoned child's wagon, in another, a section of steel bed springs. Green pots are stacked on the bed of small pottery sherds that is laid on top of the grate, and larger sherds are arranged in a protective shell around and over the new pieces. Prehistoric potters used wood fibers for fuel, but livestock introduced by Spaniards blessed the Indians with a more consistent, slower-burning combustible: slabs of dried sheep or cattle dung from the corral are stacked like a hive to surround the stacked pottery. Much care is taken in arranging the fuel, which, for an even burn, is ignited at several points simultaneously with juniper-bark kindling.

Firing can take from a half-hour to more than two hours, at temperatures averaging 1,300° Farenheit. Throughout the firing, the potter fusses around the perimeter, gauging the heat and repairing the open-air oven with new slabs of fuel. If the humidity is right, and no wind jumps up, the pottery emerges so brittle that it will ring like a bell when gently tapped with a fingernail. After the pots have cooled, they are rubbed clean of ashes and shined with a greasy cloth.

Completing its bath of fire, a southwestern Indian pot cannot be compared with sun-dried curios, glazed wares from south of the border, or factory-made ceramics fired in a kiln. Each Indian creation is of itself; from the dawn of the art in the Southwest, no two pieces of pottery have been fashioned exactly alike.

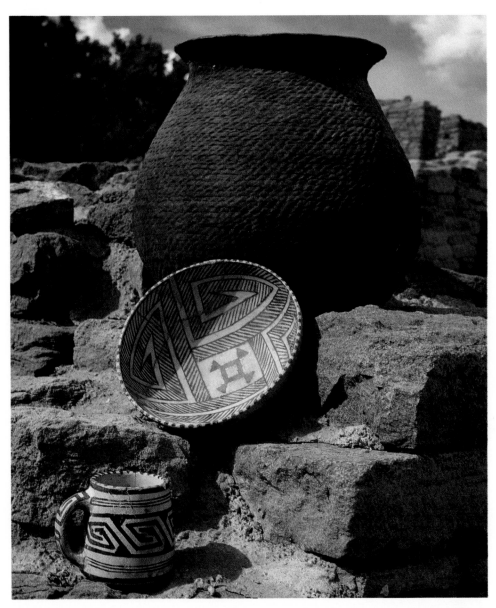

Classic Mesa Verde pottery: from top to bottom, *corrugated pot; black-on-white bowl; and black-on-white mug. Courtesy of Aztec National Monument, New Mexico. Photograph by Jerry Jacka ©1985*

2

Pottery:
Humanity's Rear-View Window

WORLDWIDE, few of humankind's activities have persisted for 2,000 years in the same place. Yet potters at work today in the American Southwest carry out ideas and employ techniques handed down through some sixty generations of geographic kinship.

Opaque it may be, but pottery affords one of the clearer windows to the unchronicled past. Fired clay retains color and pattern, resists erosion and weathering, and records an original shape even when smashed to sherds. Pottery reveals much of the lifeway, prosperity, and artistry of cultures long after their homes, clothing, and adornments have crumbled to dust. From ceramic scraps, archaeologists infer migrations, conquests, droughts, alliances, plagues, and social refinements.

Some experts presume that dishes, cook pots, utensils, and water jugs were fashioned and baked as early as A.D. 500 in what is now the American Southwest. Much of this early production was decorated, primarily with paints but also by sculpting and incising. The high quality of early southwestern pottery presents a mystery. Was the craft developed elsewhere and imported intact? Or did remarkably adaptive tribes spontaneously devise wares both useful and handsome.

Findings announced in 1984 by investigators at the University of Arizona, Tucson, tell of agriculture spreading rapidly—in a matter of a few generations—throughout the Southwest 2,100 to 2,200 years ago. The age of corn cobs and other organic farming litter was established with relative precision by means of an advanced type of mass spectrometer. Thus, fresh evidence was added to an already-plausible scenario: a South American ceramics tradition flourished at least twenty centuries before Christ; both agriculture and its tandem skill, pottery making, advanced through Central America and Mexico; then, from the valleys and highlands that today comprise Chihuahua, Mexico, and the Sierra Madre Range, the well-developed techniques of farming and ceramics were introduced into what is now the American Southwest—lands heretofore sparsely populated by nomadic hunters and gatherers.

As noted in 1974 by Peter J. Pilles Jr. and Edward B. Danson, then with the Museum of Northern Arizona:

> Since the pottery of this period is very well formed and shows none of the developmental stages that would be expected if pottery were independently discovered in the Southwest, it is thought that actual people and potters from Mexico

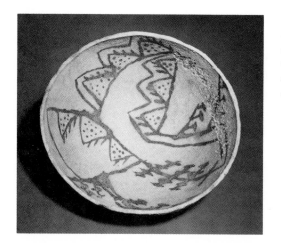

Lino black-on-gray bowl, ca. A.D. 650, recovered from Wupatki burial excavation, courtesy of the Museum of Northern Arizona, Flagstaff, Arizona. Photograph by Jerry Jacka ©1985

moved into the area. A thin brownware pottery, sometimes coated with a red slip and often quite highly polished, seems to have been well-established. These early pots are remarkably symmetrical and the vessel walls are very thin, in some cases being only two millimeters thick. It is interesting to note that some of the technically finest pottery . . . dates from this early period.

Other authorities lean toward a more localized and independent evolution of southwestern pottery making. To them, and to numerous native Americans, pottery making slowly and logically derived from the excellent baskets fashioned by peoples who occupied Four Corners (where present-day New Mexico, Colorado, Utah, and Arizona join) as long ago as 5,000 B.C. To these theorists, the farming of corn, squash, and beans in the Southwest likely predates the building of the pyramids in Egypt. Fire-baked clay basket linings recovered from archaeological sites seem to provide a reasonable bridge between basketry and pottery.

More than fifty years ago, Marjorie Lambert, then curator of archaeology at the Museum of New Mexico, attributed the appearance of polychrome (multicolored) pottery to local evolution:

While it is true that the concept of making clay pots came into the Southwest from Mexico, pottery-making developed, in most of this area, little affected by outside influences. A few examples of polychrome pottery have been found in late Basket Maker sites, and Pueblo I and II remains. However, most polychrome pottery made by southwestern Indians dated to the eleventh century, and also continues to the present time.

Some archaeologists believe that the idea of polychrome pottery came through contacts with Indians from Mexico, but, in the light of present evidence, there is even a stronger possibility of this style developing on its own in the Anasazi Southwest.

Her opinion was supported by Frank H. H. Roberts Jr., then director of the Smithsonian Institution:

I believe that the general opinion of the archaeologists who have worked in those locations, Tularosa and Mimbres areas in New Mexico and the ruins of Sikyatki in Arizona, is that most of the pottery designs were developed locally. There may have been some influence from Old Mexico at a fairly late date, but by that time the style of decoration had become firmly established. There are some districts in extreme northern Mexico where pottery with somewhat similar designs are found. The idea held at this time is that their appearance in that area was due more to a southward extension of influence from what is now the United States rather than the reverse.

Fifteen hundred years ago in the American Southwest, there prospered about two dozen pottery manufacturing groups, each with distinctive wares. In this part of the world the potter's wheel was unknown and a majority of the pieces went undecorated.

However, earthenware sometimes served as vehicles for artistic expression. Early designs began as casual lines and dots, became organized rows along lines and angles, evolved as interlocking hooks, scrolls, rectangles, triangles, and solids interspersed with cross-hatching. In lands of precious water, symbols of rain, clouds, lightning, and aquatic creatures influenced decor. Potters abstracted impressions of birds, game animals, and humans at play and work. By 1400, when nearly all the prehistoric peoples of the Southwest disappeared as cultural units (for reasons still not fully understood), they left the earth littered with durable records drawn and sculpted on clay.

Some sherds tell of being coiled and thumped into shape between a wooden paddle and a hand-held anvil rock. Other relics bear evidence of coiling by hand, pounding with a stone, and scraping with a tool. Here, pottery was hardened to gray and white in an oxygen-scarce fire; there, utensils took on reds, yellows, and browns from fires fed abundantly with air. Shapes ranged from pitchers to scoops to plates to ladles to jars to effigy vessels. Even older remnants document the days of women who found time and inspiration for artistic flairs: rippled indentations, geometric patterns, cubist paintings of spiritists. So diverse was the production of prehistoric potters that today's language of archaeology embraces more than five hundred descriptions of prehistoric pottery of the American Southwest—not to mention classifications of variants and subtypes.

Yet, for all of its preoccupation with specialties, archaeology continues to divide prehistoric pottery-making peoples of the southwestern region into three major cultures: Mogollon, Hohokam, and Anasazi.

Humans certainly occupied the Southwest some 15,000 years ago, perhaps earlier. Nomadic hunters of mastadon, camel, and giant ground sloth, these fortunate, few small bands have been likened to contest winners set free in a butcher shop. But by 6000 B.C., the big, vulnerable beasts were extinct, and successive southwestern hunters were obliged to prey upon smaller, swifter game: bison, fowl, deer. The Mogollon inherited a hunting tradition as well as prime hunting grounds. They began to assert their ways in the mountains of today's New Mexico and Arizona at about the time of the birth of Christ. The pottery of the Mogollon progressed from plain but expertly manufactured thin-walled wares to painted red-on-brown designs, incised and pinched textured surfaces, and red-on-white types with black smudged interiors. About A.D. 950, the Mogollon potters adopted broadline patterns in black-on-white paint. Foragers that they were, and early dry farmers, the Mogollon people depended upon all manner of ceramic wares. By 1100, when the Mogollon were exhibiting Anasazi-like traits, their pottery shapes and colorations had proliferated as beautiful White Mountain redware, St. Johns polychrome, and Tularosa and Reserve black-on-whites.

To the modern eye, most startling are the surviving creations of the Mimbres, a distinct Mogollon group who occupied the forty-six-mile-long Mimbres Valley of southwestern New Mexico. Within fine lines and balanced panels, Mimbreños potters enlivened their bowls with bugs, animals, fish, water symbols, geometrics, and so many male human hunters that there is speculation that the potters were men. Mimbreño dead were buried beneath the floors of houses and many picture bowls were recovered from such burials. The fate of the Mimbres people remains a puzzle, yet their picture stories are so fresh that (as

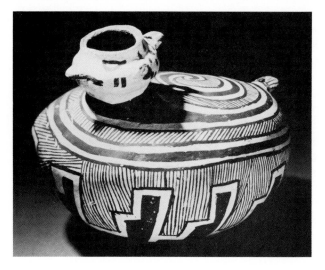

Tularosa-style effigy jar, Reserve black-on-white. Photograph by Jerry Jacka ©1985

14

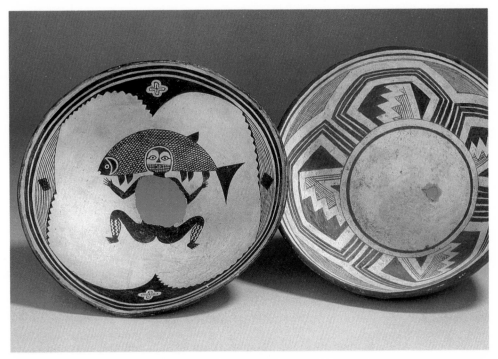

Mimbres black-on-white bowls, courtesy of The Heard Museum, Phoenix, Arizona. Photograph by Jerry Jacka ©1985

Tony Berlant has written), "like love notes from a distant culture, they reassure us that the human spirit is immortal. Through them, immortality is granted to the vanished Mimbres themselves."

HOHOKAM

Master farmers and community organizers, the Hohokam made much of the arid lands of southern Arizona. In a thousand years of occupation (beginning at about the time of Christ), the Hohokam irrigated forty thousand acres of vegetables, fruits, and fiber plants (primarily cotton) with a five-hundred-mile system of precisely engineered canals. Main water arteries were as wide as seventy-five feet and as deep as twelve feet; large desert cities were sustained as far as six miles from the nearest river. So successful were the Hohokam in focusing their economic and social energies that they were able to export surplus cotton and grain. They etched seashells, imported from Mexico or perhaps the Pacific coast, with cactus acid; cast copper bells by the lost wax method; fabricated mosaics of turquoise; wove cotton into cloth; carved stone vessels; domesticated the dog; and adorned their bodies with

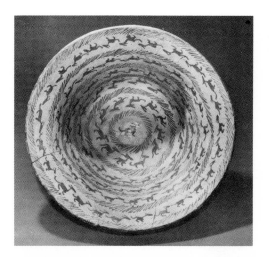

Interior of Hohokam Santa Cruz red-on-buff piece. Photograph by Jerry Jacka ©1985

bracelets, rings, earrings, and pendants. It is supposed that Hohokam athletes competed in a game played with a rubber ball on a large court of packed clay; perhaps they worshipped at temples that echoed those of the Aztec.

The Hohokam painted their pottery: red-on-buff designs prevail on bowls, jars, and water bottles. Repetitive parades of human and animal figures march around Hohokam pottery shoulders and rims. Toward the end of the Hohokam as a cultural entity (ca. 1400), their ceramics drifted away from red-on-buff painting to a mix of redware, brownware, and painted designs related to those of other nearby peoples.

ANASAZI

Ancestors of modern-day Pueblo Indians likely were a prehistoric people known today as the Anasazi, a Navajo word meaning "the old ones." Nomadic, semiagricultural, the early Anasazi were such accomplished weavers that pioneer archaeologists gave them another name: Basket Makers (A.D. 100–700). Evolving from pit houses to masonry apartments on the high plateaus of Utah, Colorado, Arizona, and New Mexico, the Anasazi did not become potters until A.D. 400–500. Early pottery was generally slipped with white and painted in black, although storage and cooking vessels might be of undecorated, spiraled, corrugated coils. The great pueblo centers of Chaco, Mesa Verde, and Kayenta carried the idea into thin, flinty, burnished, black-on-white wares. Of timeless appeal are the remarkably modern Anasazi mugs that gave the name to Mug House, one of the larger structures on the western edge of today's Mesa Verde National Park in Colorado. Squat, loop-handled, averaging a generous pint in volume, the mugs of Mug House would wear their bold, pleasant scrolls, triangles, frets, and zig-zags well at a twentieth-century office coffee break.

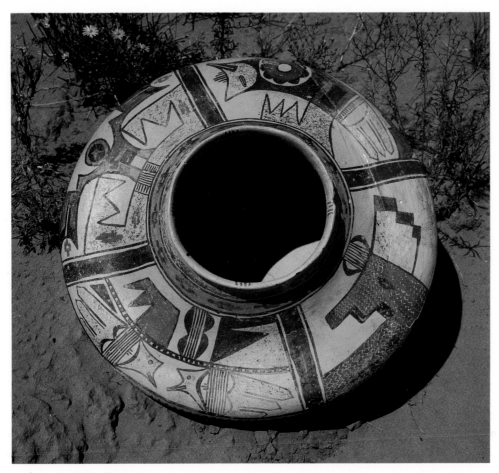

Sikyatki polychrome jar, courtesy of the Hopi Cultural Center, Second Mesa, Arizona. Photograph by Jerry Jacka ©1985

By the time of the Spanish invasion of the mid-1500s, the Anasazi people had abandoned the sprawling cities of the northern plateau country. The black-and-white, corrugated tradition gave way to glazed finishes at Pecos and Zuni and polychromes known today as Sikyatki, Four-Mile, Gila, St. Johns, and other types.

Southwestern Indian pottery on the market today is divided usefully into three broad categories: prehistoric, historic, and contemporary. The first term is applied to pieces produced prior to Spanish contact—Coronado's army in 1540–41 in the opinion of some,

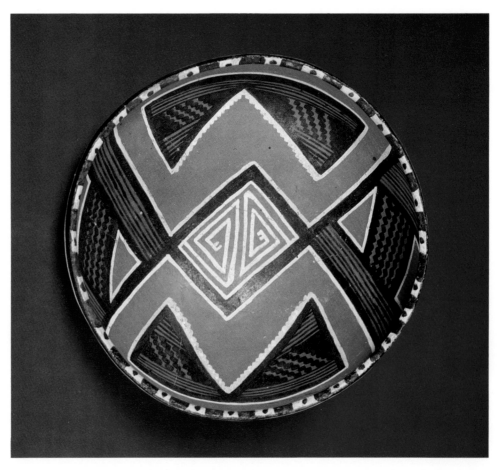

Prehistoric Four-Mile polychrome from central Arizona, ca. A.D. 1300–1400. Photograph by Jerry Jacka ©1985

and surely no later than Spanish colonization some six decades later. The impact of Spain on the pueblos is manifest; upon their pottery (categorized as historic), not so apparent. Perhaps bowls increased in size to accommodate Spanish wheat; theretofore familiar forms from Spain itself were introduced to Pueblo potters. In the representatives of viceregal Spain, the native potters acquired a new cash and barter market.

Yet pottery meant more than material worth to Indian artisans. They made pottery in the old ways for their own homes. Even when such expression was forbidden, through artistic embellishment potters spoke of their ageless religion and ingrained values. For example,

although the burying of pottery with the dead was discouraged, ceremonial pieces were made in secret and hidden away. As often happens in the attempted subjugation of an entrenched society, the banning of an art ensured its survival.

Unease and outright violence bedeviled the Spanish colonies in the latter half of the seventeenth century. An attempted revolt in the mid-1600s brought swift and brutal retaliation; by 1680, the pueblos had clandestinely unified under the leadership of the mystic Popé and drove four thousand Spaniards back to what is today El Paso, Texas. Indians who had collaborated with Spain feared for their lives, and some fled, taking their ideas and art to more sympathetic tribes and villages.

In 1692, Diego de la Vargas reconquered the pueblos of the Rio Grande River Valley and more dislocations followed. An unsuccessful rebellion four years later caused even more discontented Indians to move from their villages—some eastward to fall in with friendly Plains tribes, some westward to kindred Hopi villages, some northward to the San Juan River home of the Navajo.

Not all Spanish influences were negative. Spaniards introduced higher-yield grains, fruits, and Old World and Mexican vegetables. Puebloans acquired donkeys and horses and sheep and learned the production, weaving, and dying of new fibers. They may even have copied the beehive oven from Spanish bakers.

Although prehistoric southwestern pottery had been collected with great fervor by early American ethnologists, little interest was taken in historic pottery until 1880, with the arrival of the railroad. With trains came tourists, and tourists demanded cookie jars, salt cellars, sugar bowls, and ash trays. More traditional examples of the historic period were assembled at Zuni and other pueblos by James Stevenson and Victor and Cosmos Mendelhoff and dispatched to the Smithsonian Institution. Yet, into the twentieth century (when the contemporary period begins), the tourist trade provided nearly sole financial support for southwestern pottery manufacture.

What sets southwestern pottery apart from any other in the New World is that prehistoric techniques, forms, and designs outlasted incursions of Spaniards, Mexicans, and Americans. Pueblo Indians and other tribes of the Southwest had full access to cheap and efficient containers and utensils for home use. The iron skillet, the china plate, the tin cup, the glass bowl, and the copper kettle made obsolete the practical technology of clay pottery. Financial support from tourists and advice from well-meaning outsiders further eroded the art. As one observer wrote:

Just as the Indians were switching to, rather than fighting, the new technology, they were discovered by the first wave of anthropologists. The Indians were informed that what they were doing, useful though it might have been, was really indigenous aboriginal art.

They obligingly set to work churning out crockery at a furious rate. Told that a

design she'd dreamed up only that morning was a "classic three-clouds pattern," a smart potter cranked out classic three-cloud patterns for years, or until they *became* classic.

Rescue of the integrity of southwestern pottery can be credited to relatively few individuals—both Indian and non-Indian—who kept faith in the high standards of native forebears. Credit for nurturing their people's crafts is accorded to two remarkable ceramic artists.

Nampeyo, a Tewa woman living at Hano in the Hopi First Mesa area, took notice of ancestral prehistoric pottery being excavated by archaeologists at Sikyatki. Using sherds of pottery dating from the fifteenth and sixteenth centuries, Nampeyo copied long-forgotten shapes and decorative styles. Nampeyo not only sparked a renaissance in fine Hopi ceramics, but also ensured the revival of a legitimate Puebloan tradition of excellence.

Another turn for the better in the first part of this century is attributed to María and Julian Martinez of San Ildefonso Pueblo, New Mexico. Experimenting with a style found among the ruins of Pajarito Plateau, María began in 1919 to bring forth splendid gunmetal-black polished wares, decorated with Julian's precise matte designs. Their fame increased with publication of Alice Marriott's 1940 biography, *María, the Potter of San Ildefonso.* María and Julian's artistic and commercial success encouraged relatives and neighbors to reclaim their birthright, and excited potters of other communities, hundreds of miles distant.

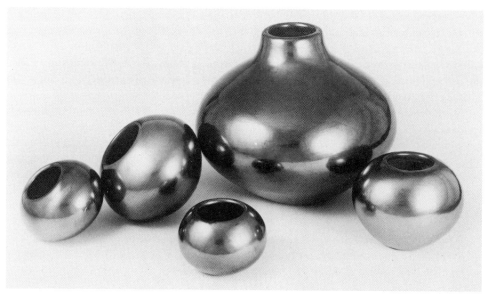

Highly polished blackware by María of San Ildefonso. Photograph by Jerry Jacka ©1985

Anglo encouragment for such achievements came from the likes of Dr. Kenneth M. Chapman and Dr. Edgar L. Hewett, famed anthropologists. Institutions and collaborations of scientists sponsored morale-boosting shows and competitions, while other non-Indian sympathizers transformed a casual commerce into the Southwest Indian Market at Santa Fe, where serious potters could realize better compensation for their time and talent. Out of a social gathering in the Santa Fe home of Elizabeth Shepley Sergeant grew the Pueblo Pottery Fund, later incorporated as the Indian Arts Fund. Including the personal donations of such *aficianados* as Dr. Chapman, Laura Gilpin, Frederick M. Hodge, Alfred V. Kidder, Mabel Dodge Luhan, Dr. Harry P. Mera, Mary C. Wheelwright, and Amelia Elizabeth White, the collection today exceeds six thousand items. Many acquisitions and functions of the Indian Arts Fund are preserved and advanced at the Indian Arts Center, one of the numerous Santa Fe institutions devoted to academic and artistic appreciation of native ceramics. Supporting markets prospered at Albuquerque and Gallup; the Exposition of Indian Tribal Arts in 1891 in New York attracted international attention; and now into its sixth decade, the Museum of Northern Arizona in Flagstaff promotes annual Indian crafts exhibits. Potters respond to markets with study groups at pueblos, notably San Juan, Santa Clara, and Santo Domingo. Today, these revival movements persist with younger potters who descend from the original occupants of the American Southwest. In the words of anthropologist Clara Lee Tanner,

No greater craftsmanship is found elsewhere in a period comparable to the neolithic of native prehistory. Neither in new stone-age Egypt nor in neolithic Greece will one find ceramic expressions which exceeded in attainment these native accomplishments.

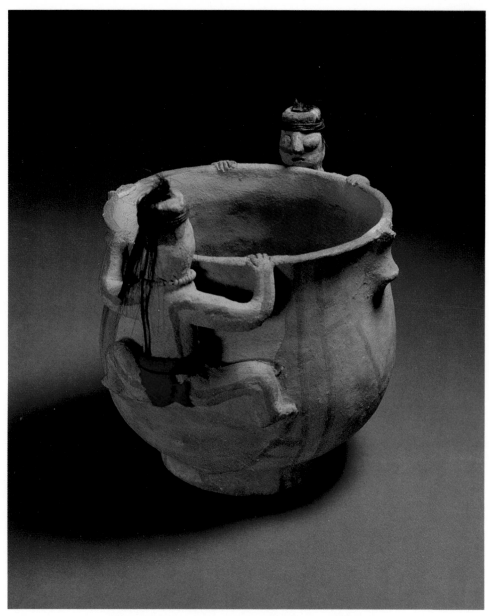

Yuma pottery vessel, courtesy of The Heard Museum,
Phoenix, Arizona. Photograph by Jerry Jacka ©1985.

Pottery and Potters
of Arizona

THERE WAS A TIME when all the tribes whose descendants now reside in Arizona produced pottery to some degree. The Yuma, the Pima, the Papago, the Cocopah, the Mohave, the Havasupai, the Hualapai, and the Yavapai of the state's western rivers and central mountains fired pottery, some finished plain for utility and some decorated. The mobile Apache traveled with ceramic canteens, and their cooking jars had pointed bases so that they could be shoved into beds of coals. Papago and Pima Indians made red, black, and cream wares echoing the work of their ancestors, the Hohokam.

Today, there are but three main groups of potters in the state, and each perpetuates a plausible explanation of why their art survived. By coincidence, the remaining scattered pottery makers represent greatly diverse earlier cultures: Puebloan, Athabaskan, and Yuman.

HOPI

Some fifty-two hundred Hopi and Hopi-Tewa today live in a dozen villages on and under the mile-high mesas of northeastern Arizona. Some communities have been continuously occupied since the 1500s. Despite four and one-half centuries of cultural upheaval visited upon them by outlanders, the Hopi people retain much of their traditional religion, language, and lifestyle, including the cultivation of crops in a land of little rainfall and short growing seasons. Thought to descend from ancient Puebloan cultures, the Hopis once made fine pottery, but by the middle 1800s, the craft had deteriorated and in some villages, ceased altogether. The manner in which pride and pottery-making were restored to the Hopi is testimony to the impact of one purposeful individual.

Long ago, a band of Tewa Indians fleeing Spanish oppression in New Mexico found refuge in Hopiland. They were allowed to establish the village of Hano, on First Mesa near the Hopi village of Walpi, where pottery-making had almost ceased.

One of the Tewa men whose family had settled in Hano was employed as a laborer in the excavation of a prehistoric Hopi site, Sikyatki, and he showed recovered pottery relics to his wife. She, Nampeyo by name, was motivated by their beauty to improve her own pottery. Drawing upon polychrome Sikyatki designs and shapes, Nampeyo soon developed a style that was recognized for its high quality and was accepted both on and off the reservation. Daughters, granddaughters, and other women of First Mesa (both Tewa and Hopi) picked up and developed Nampeyo's skills. Thus, the influence of this Tewa potter—who died in

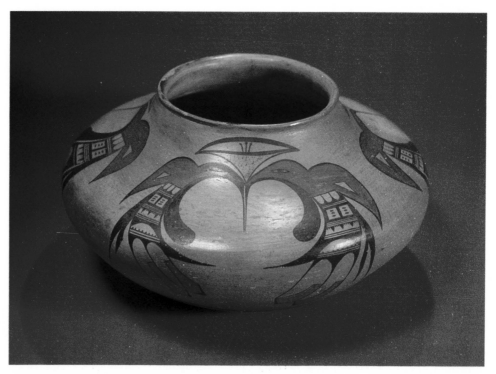

Pottery jar by Nampeyo. Photograph by Jerry Jacka ©1985

1942 at age eighty-two—runs vibrantly through Hopi art today, not only in pottery but also in silver jewelry, basketry, and painting.

Generally, Hopi potters make two forms of vessels: bowls and jars. Decorative rectangular tiles or wall plaques, bearing uniform designs, are fired for the tourist trade, as are canteens, rattles, and covered jars.

Most good Hopiland clay requires no temper. After construction, Hopi-Tewa pots are ground smooth with a sandstone; some pieces are polished with pebbles. For firing, the potters mine a local, low-grade coal, which is combined with cedar wood and sheep dung. First Mesa potters make their paints: for black, extraction of tansy mustard mixed with hematite; for red or orange, iron hydroxide; and for white, fine clay. The brushes of old—rabbit's tail—are giving way to cloth and commercial paint brushes.

Hopi design is characterized by an urge to fill out the available field and an eye for unity, even in asymmetric motifs. These traits are best demonstrated in the Hopi treatment of "rain parrot" displays—whirling feathers, eyes, beaks, and tails, which, for all of their variations in size and shape, somehow attain a perfect, flowing balance. Other designs include

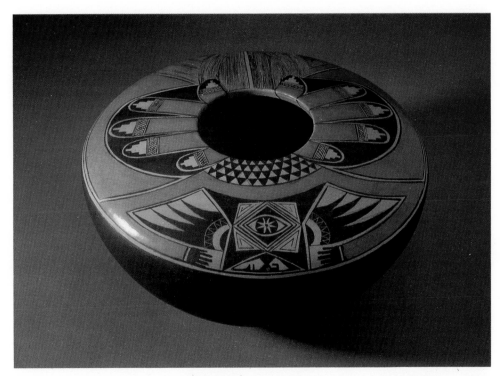

Seed jar by Hopi ceramist Dextra Quotskuyva. Photograph by Jerry Jacka ©1985

kachinas (personifications of Hopi gods) and combinations of elements that suggest the summer thunderstorms that are so crucial to Hopi agriculture. Bowls are usually decorated on the inside, while jars carry their designs on their exteriors.

Completed pottery can be of several types: one with a variegated buff-orange base, slipped or unslipped and painted in black and red; another slipped with white; and a third either solid or slipped with a yellow clay that turns almost maroon in firing. One popular clay emerges from the fire mottled orange to cream, and the mottling becomes an important part of the design. The heavy wares have a dull, wooden ring.

Utility pieces are also routinely produced on all the Hopi mesas, in nearly all the villages. These pieces—large cooking vessels, storage jars, and big water pots lined with piñon gum—are sometimes offered for sale. Although unartistic, these wares also reflect the Puebloan instinct for proportion.

The outlook for pottery-making in Hopiland is excellent. Some of the best pottery of the period, much of which echoes historic work, is being made now, and rising prices encourage the potters to increase and refine production. Among the better known potters of

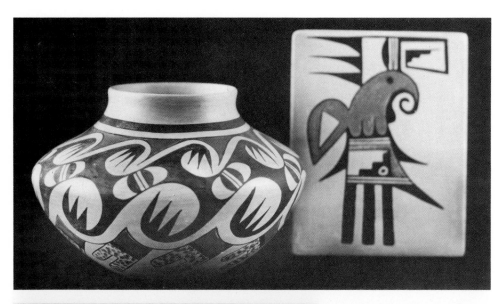

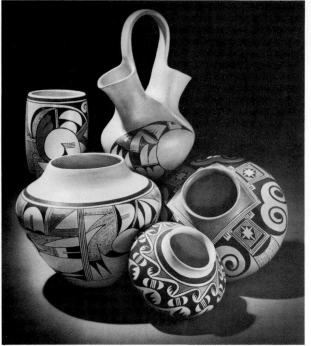

Above: *To complement the sensuous, recurved sculptures of contemporary pottery, Hopi ceramists also fire rectangular tiles bearing abstract designs.*

Left: *Hopi pottery reflects a whirling symmetry.*
Photograph by Jerry Jacka ©1985

recent times are Lovena Adams, Sadie Adams, Mary Ami, Grace Chapella, Verla De-
wakuku, Marcia Fritz, Vina Harvey, James Huma, Violet Huma, Rena Kavena, Loma
Kemo, Helen Naha (Feather Woman), Fannie Nampeyo, Eunice Navasie (Fawn), Joy
Navasie, Paqua (Frogwoman), Garnet Pavetea, Al Qöyawayma, Alma Tahbo, Elizabeth
White, and Wallace Youvella. Both Qöyawayma and Youvella are said to experiment with
non-traditional ceramics, but the men insist that their inspiration derives from the very old
Hopi artifacts displayed today in distinguished museums such as the Smithsonian and the
Heard.

NAVAJO

"Beauty is only skin deep," a self-styled wit once said, "but ugliness goes to the bone." One
thinks of the pottery of the Navajo Indians, most numerous of the modern American tribes
and a group whose artistic accomplishments are so superior in other media such as weaving,
painting, and silversmithing.

Perhaps the homeliness of Navajo pottery is rooted in the people's early wanderings. Do

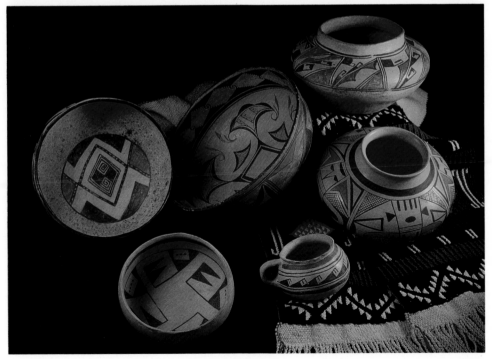

Centuries of Hopi art tradition, courtesy of Cary W. Carlson. Photograph by Jerry Jacka ©1985

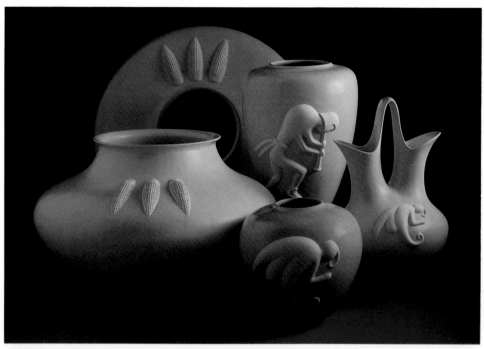

The work of Hopi artisan Al Qöyawayama, contemporary in execution, ancient in inspiration. Photograph by Jerry Jacka ©1985

Gypsies, who pack and unpack every few days, drink from crystal stemware? Would Navajo women take pains with pottery that could easily break in moves from camp to camp?

Contemporary Navajoland is as large as West Virginia, with a population of some one hundred eighty thousand centered in northeastern Arizona. From such a vast crucible the pottery varies greatly in form. More than two hundred years ago, Navajos of New Mexico fashioned a kind of decorated pottery, but that is now lost. Another traditional form resembles an enlarged minié ball (that Civil War bullet with a conical point and hollow base). In use, the pointed end of a Navajo pot enabled it to stand in a bed of coals. Also available now are flat-bottomed flower vases, squat jars, double-necked vessels, smoking pipes, tall ollas with scalloped rims. Name it and Navajo women make it.

Features found in most items included unevenness of walls, biased constructions, gritty surfaces, mottled black and brown coloration, and decoration, if any, limited to simple sculpting or clay beads near the mouths of the pieces, placed as if to improve the grip. A new trend, however, is toward applique, with designs depicting plants, animals, and human figures. Many Navajo pots are casually swabbed inside and out with a wash of piñon pitch,

giving the appearance of glaze.

Certain *aficianados* of southwestern craft art discern a charm in Navajo pots. Undeniably, genuine Navajo pottery is within reach of every pocketbook. Contemporary Navajo pottery sells for as little as twenty dollars and grand pottery drums, a foot in diameter, may be purchased for one hundred dollars to three hundred dollars, depending upon the market. Names to look for are Silas Claw, Stella Claw, Alice Cling, Betty Manygoats, Emmett Tso, and Rose Williams.

MARICOPA

Before Spanish times, the Maricopas lived on the Lower Colorado River. Dogged by enemy tribes, the Maricopa drifted eastward to ally with the Pima in battles against the Yuma,

Inexpensive though they may be, today's Navajo wares are intriguing with their understated ornamentation and glaze of piñon pine pitch.

The pointed base of this utilitarian Navajo jar derives from nomadic days when utensils were thrust into beds of coals for cooking food.

Mohave, Yavapai, and Apache tribes. When the white man parcelled out land for reservations, the Maricopa shared living space and government with the Pima on the Gila and Salt rivers. Today, among some two hundred Maricopa, vestiges of the old culture remain: cremation before burial, faultless hospitality, a philosophy of harmony, and a language separate from other southern tribes. As a Maricopa oldtimer, Charlie Cough, lectured his sons before he died, the Maricopa believe that "to help another person is the way of a good man. To be a partner with nature is the path of goodness. There is no room in the good heart and soul for greed."

In an early division of labor, Pima women concentrated on basketry, while their Maricopa sisters specialized in pottery. In a familiar story, high standards of Maricopa ceramics declined as the European presence increased. Again, one woman is accorded great credit for rescuing an all-but-lost birthright.

Ida Redbird was born in 1893; her father was Maricopa and her mother was Pima. Thus, her pottery came to reflect the historic styles of both peoples. While all around her accelerated the growth of American civilization—horse trails into freeways, squash patches into ten thousand-acre food factories, stage stops into towering modern cities—Ida kept her hands in clay. She concentrated upon a shiny ware, basically brick-red but sometimes relieved by gray-white bands and decorated with repeated geometric design elements painted in black.

Trains rolled past her door; Ida Redbird tasted her clay to make sure the salt content was not so high as to speckle in firing. Jets roared overhead; she experimented with most artistic long-necked ollas in unpainted styles. As her fame increased, she traveled, ever serene and

smiling, to demonstrate her skills at Indian shows and tribal fairs. She generously taught other Maricopa potters. Still, at her productive peak in the 1940s and '50s, her profit on a magnificent twenty-inch-tall olla might amount to only one dollar and twenty-five cents.

A large needful family ensured that by the 1970s, Ida Redbird was still dwelling in a two-room adobe shack; plumbing consisted of one outdoor faucet. Gifts of a refrigerator and television were worthless, since there was no electricity. Arthritis and diabetes did not keep her from long hours at the scrub board, however, washing her own and her grandchildren's clothes. And one day, while she slept beneath a tree, a great limb fell and killed her.

Today, in a very tangible way, she lives. Her styles are continued by Vesta Bread, Barbara Johnson, Mary Juan, Alma Lawrence, Anita Redbird, Malinda Redbird, Sundust, Mabel Sunn, and Elva Yaramata. They produce redware that some critics judge to be technically equal to Ida's. Also produced are some black-on-cream in simple, graceful forms: bowls, jars, and long-necked ollas. While the work is aesthetically pleasing unpainted, the trend nevertheless is toward design. Frets, steps, solid triangles, and open spirals are shakily drawn in black, which, if natural, is extracted from mesquite. Frogs, modeled and outlined in black, are the commonly paired figures on so-called effigy bowls.

The future of Maricopa pottery-making seems bright, again for economic as well as artistic reasons. Medium-sized excellent Maricopa wares today command fifty dollars to one-hundred dollars, and with the close attention and encouragement of the Gila River Arts

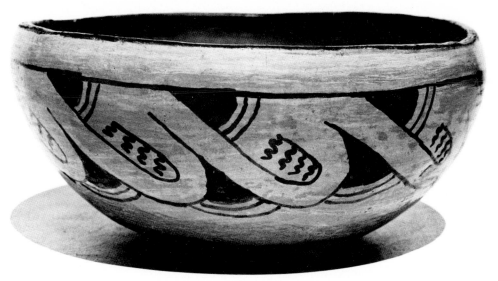

Well-polished Maricopa pottery bowl with red interior and black-on-white exterior design, ca. 1950.

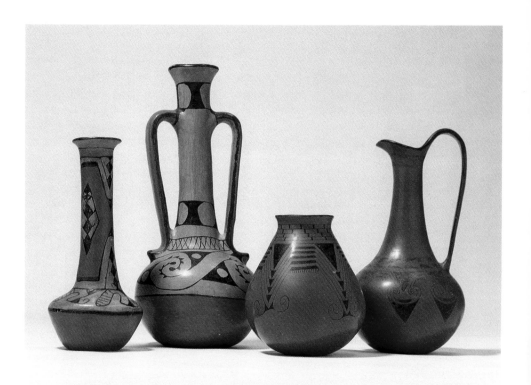

Maricopa pottery, courtesy of The Heard Museum, Phoenix, Arizona. Photograph by Jerry Jacka ©1985

and Crafts Center near Sacaton, pottery-making is becoming financially worthwhile for its practitioners. Too late to benefit Ida Redbird, museums and private collectors are now willing to pay almost any price for her works.

OTHER ARIZONA POTTERY

While pottery-making among other native peoples has ceased, some knowledge endures. From time to time, here and there, potters attempt to resurrect vestigal skills. Economic incentives may reactivate pottery-making where the know-how exists. Still living are Pima and Papago women with knowledge of the stone anvil–wooden paddle technique inherited from the Hohokam. Their pottery, when they attempt it, is much like that of the Maricopa, but thicker of wall and decorated with floral and figure designs. Coloration ranges from plain polished brown to black-on-white and black-on-red.

The works of the late Annie Fields, a Mohave potter famed for her ceramic frogs bearing

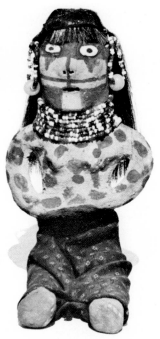

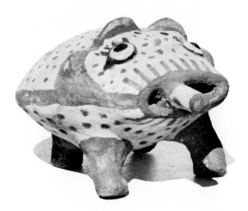

Mohave frog and woman effigies; the woman effigy has a beaded necklace and human hair. Ca. 1950.

firebrands (in Mohave myth, the frog brought fire to mankind) are much prized by contemporary collectors. Betty Barrackman, wife of a Mohave tribal leader, is producing effigies, small bowls, and effigy dolls in traditional ochre-on-buff. The pieces, fired in a kiln, are signed "Norge," Mrs. Barrackman's clan identification.

Cochiti storyteller figure by Helen Cordero, courtesy of The Heard Museum, Phoenix, Arizona. Photograph by Jerry Jacka ©1985

Pottery and Potters
of New Mexico

OF FORTY THOUSAND PUEBLO PEOPLE, some twenty-eight thousand today dwell generally where the dons of Spain found them in the middle of the sixteenth century while searching for gold. Spaniards gave them their name: Pueblo, meaning the people of a village or communal dwelling place. Pueblo country today reaches from Zuni in an arc northeastward across the Rio Grande Valley as far as Taos. When military conquests, colonizations, impositions of governments and church-building that accompanied Spanish, Mexican, and U.S. sovereignty are considered, the survival of the pueblos as distinct units is an extraordinary example of human adaptation.

Accommodation has ever been a Puebloan strength. About a thousand years ago, their ancestors, the Tanoans, coped with a great drought by irrigating fields from the Rio Grande and its tributaries. In the 1300s, another group of people appeared, Keresan dry farmers. From the Tanoans, the Keresans learned technology. In exchange, they shared their mystical philosophy, one based upon harmony with spiritual and natural worlds.

In 1540, there were sixty-six pueblos. Three centuries later, the population was reduced by one-half. Villages were abandoned or relocated, and all of the remaining villages had Catholic churches. The main language became Spanish, and the economic base was altered. Puebloans farmed exotic species of plants, wove textiles in a different way, and tended livestock that came from another hemisphere. With the assumption of American control in the 1840s came new land-use policies and a new tongue, English. Again, the Pueblo people bent but would not break.

In today's eighteen New Mexican pueblos, the people cling in varying degrees to their languages, their religions, their adobe-stone buildings, and their systems of assigning land. Local governments are autonomous, and largely democratic. In some cases, authority is symbolized by ebony, silver-mounted canes issued by President Lincoln in 1863.

The Pueblo capacity for absorbing cultural shock is revealed in twentieth-century pottery production. Before 1900, when nearly all pottery was made for home use, colors tended toward black-on-white, cream, or red backgrounds; some polychromes; and relatively few pieces of unadorned blackware.

Then, catering to tourists and traders, potters turned to burnished black-and-red wares, and combinations of matte and polish. Form became . . . everything. Non-Indian ashtrays, dinner plates, and cookie jars were plastered with garish poster paints, and sizes diminished. "Design in Rio Grande pottery seems to have followed the trends of other aspects

of the craft," wrote Clara Lee Tanner.

In other words, as long as the products of the ceramist were for native use, design followed heavily traditional paths. But when commercialization began, design became more simplified, often was executed with less care and artistry, and many times degenerated into a real curio style. Some individuals did and still do maintain high standards and certainly this comment does not pertain to them. In fact, it is they who are keeping southwestern Indian ceramics within the realm of a true and highly artistic craft expression.

Although the quality is uneven, pottery is currently made in sixteen of the eighteen New Mexican pueblos. By one expert's estimate, some two hundred and fifty Pueblo potters deserve the title "professional" in that they are able to derive most of their income through the production and sale of ceramics. Generally, the pieces express origin and meaning through shape (usually symmetrical) and surface treatment (polish, coloration, decoration, and sculpting). As in ancient times, differing clays identify villages and their potters. More from Dr. Tanner:

The results obtained by some of these potters often can put to shame the painstaking cloisonné of ancient Chinese, the microscopic mosaic and intaglio of the Old Florentine craftsmen, the etching of Czech crystal artisans . . . or even the mathematical calculations of an electronic computer.

ZUNI

The status of pottery-making at the western pueblo of Zuni is not encouraging. Here, the problem is competition from another art, jewelry-making. Craftspeople can make more money as silversmiths and lapidaries; many of the Zuni women jewelry-makers were once potters.

Near the Arizona border, Zuni is the largest of the Pueblo villages, and governmental and religious center for about fifty-five hundred reservation residents south of Gallup, New Mexico. Not far from Zuni is the ruin of Hawikuh where, in 1540, the Spaniard Coronado and his soldiers executed the first military action of Europeans against native Americans within the borders of today's United States.

In early times, the Zuni people favored glazed wares, but by about 1700, a veneration of prehistoric life popularized a revival of black-on-white. The designs were charged with symbolism: crooked drum sticks, bows, feathers, prayer birds, and dragonfly water spirits. At the time of an 1879 survey, Zuni potters were in agreement regarding what a proper pot should be. Because of the coarse Zuni clay, pot walls might be lumpy but must be smooth to the touch. Flat kaolin slip covered all surfaces, to be given a base of red and designs in black lines. By custom, a band near a vessel's neck received a repeating geometric treatment,

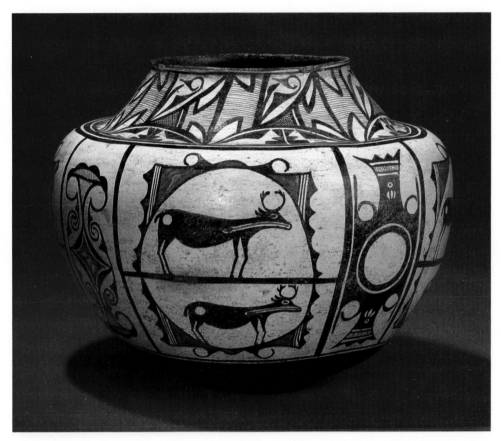

Old Zuni storage jar, courtesy of The Heard Museum, Phoenix, Arizona. Photograph by Jerry Jacka ©1985

while lower areas would be sectioned off for displays of deer, birds, and rosettes. At one point, the horizontal dividing lines were broken to provide a path for spirits. The deer were likely to have arrows piercing them, mouth to heart. The birds, long of tail and short of leg, were often painted nibbling at flowers. In modern times, these designs didn't so much change as vanish. Few, if any, bowls are made today.

In late 1984, an impressive sampling of Zuni pottery returned to the pueblo. Assembled by Dr. Margaret Ann Hardin from collections of the Smithsonian, the Heard Museum, the School of American Research, and others, the exhibit contained large, documented pieces from the nineteenth century. In her catalog, Dr. Hardin noted that "Zuni potters do not regard their clays and pigments simply as material resources. Rather, they are gifts of

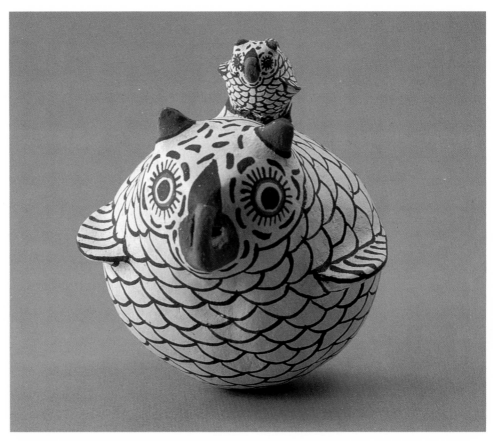

Zuni owls, rarely made today, may bear tiny owls on their backs.

Mother Earth and Clay Woman. In traditional belief, the materials used to make pottery are the flesh of these beings."

Zuni ceramic production is dwindling today, restricted by and large to a rank of humorous figurines, mostly owls. They range from a couple of inches to a foot or more in height, and may bear one or more lesser owls on their backs. Short wings, tails, and ears are modeled on the fat, round bodies, and an arch of clay indicates a beak. Feathers are drawn in black or brown, while ears and eyes are accentuated with brick-red paint.

Twenty-years ago, at the All-Indian Pow Wow in Flagstaff, Arizona, flocks of owls perched in every Zuni booth. Now the lure of silver and stone work is such that recently, when a visitor roamed up and down the lanes of Zuni booths offering to buy a Zuni owl at a premium price, he went away after a day and a half of searching, *sans* owl.

Located on a mesa 7,000 feet above sea level and 367 feet above the valley floor, Ácoma, the Sky City, considers itself senior to Oraibi in longevity. It claims the title "the oldest continuously inhabited community in the United States," reflecting an endurance of a thousand years.

Today, motorists can easily reach Ácoma by good roads fifty miles west of Albuquerque, and drive right up to the top. But in prehistoric times, the trails were purposefully difficult, affording the Ácoma people security against their enemies.

To the Spaniards, five thousand Ácoma Indians on a defensive strongpoint posed a threat. Skirmishes culminated in 1599 with a three-day battle, during which as many as eight hundred Ácomas were thrown or driven over cliffs to their deaths. Captives were tried, imprisoned, enslaved, and mutilated.

Prodigious labor forces were needed to bring Christianity to the Ácomas. Adobe for the church walls had to be carried up narrow paths, and tons of earth for a burial ground were likewise borne to the top of the mesa on the backs of the Indians. Through generations of conquest and revolt, village-sacking and crop burning, the original stone pueblo was transformed into adobe. Nearly all of the seventy-acre mesa top is now covered with mud apartments, a church, and a convent. Only a few families live atop the mesa year-around, however; most of the twenty-five hundred Ácomas prefer to stay at villages near their agricultural enterprises, returning to Ácoma for ceremonials.

Ácoma welcomes visitors, who are expected to pay reasonable fees for parking, photography, and guide services. A peek into an Ácoma home tells much of Puebloan life. Temperatures are moderate behind thick adobe walls, which are whitewashed inside at least once a year. The family's belongings hang from pegs—there may be skins, rifles, jewelry, blankets. On walls and ceilings are suspended strings of red chiles and corn, dried melons and peaches, and mutton and venison jerky. The sleeping mattresses may be rolled up and used as seats. Volcanic stones for grinding corn are enclosed in wooden boxes. A fireplace (with a chimney, a European innovation) provides warmth and light. One kind of bread, *hewe* in the Ácoma language and *piki* to the Hopis, is baked on a stone slab, the circles of bread as thin as paper. Another bread is made in an outside domed oven of plastered adobe.

As for pottery, some eighty-five years ago, pioneer photographer Henry G. Peabody was able to enter a home at Ácoma and purchase a four-color olla seventeen inches high, exhuberantly decorated, and painted in a deep red color that has been long lost to modern potters. "Ácoma styles have changed less since they were first studied in 1870 than those of almost any other pueblo," wrote Dr. Ruth Underhill in 1944. That may have been true at the time of writing, but the past forty years have quickened Ácoma commercialization.

Still, Ácoma pottery is among the best in the Southwest. None is of thinner wall. Fired hard, lightweight, Ácoma ceramics ring musically when lightly struck. Shapes these days often depart from the voluptuous oldstyle jars. Deep contemporary open-mouth bowls, angular jars, and pieces with scalloped rims would certainly puzzle a professor familiar with

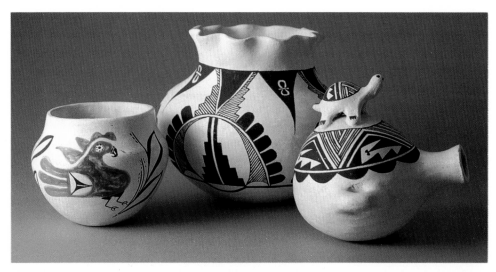

An assortment of shapes and designs offered for sale at the "Sky City" of Ácoma, New Mexico.

Ácoma pottery of the 1940s.

Still the same, though, are the pristine, dull slips of stark white, eggshell, and cream, and patterns of repetitive cross-hatching, angles and curves, or figures from nature, most commonly flowers or a parrotlike bird thought to be borrowed from Zia pueblo (this is disputed by Ácomas, who accuse Zia potters of copying the Ácoma bird!). The geometric designs are usually contrived in black only. Lines brushed on by hand are incredibly straight and even. By offsetting hatching against filled geometrics, Ácoma potters achieve dynamic effects.

Designs from nature are more often three-colored: white ground, black drawing, and touches of a yellow slip that fires yellow, red, orange, and brown. The Ácoma bird is frequently shown pecking at red berries; an Ácoma deer is pierced through the heart by an arrow. The most recent direction of Ácoma pottery is toward prehistoric design elements taken from Mimbres, Hohokam, and Anasazi relics. Highly stylized serpents, lizards, and birds are painted in black and red against white backgrounds.

By far the most acclaimed active Ácoma potter is Lucy M. Lewis, recipient in 1983 of the Governor's Award for excellence and achievement, New Mexico's highest honor. Born at the end of the nineteenth century, Mrs. Lewis learned how to make pottery as a very young girl. She sold her work along U.S. Route 66 for a few dollars each. Encouraged by success at the Gallup Intertribal Show and advice from Dr. Kenneth Chapman, Mrs. Lewis studied ancient Ácoma pottery and adapted designs and techniques to her work. With permission, she borrowed the Zuni deer-and-heartline motif. Her own pieces are on

permanent exhibition around the world, notably at the Southwest Museum in Los Angeles, the Princeton University Art Museum, and the Smithsonian.

Her descendants bring fresh expression to traditional designs. Five daughters—Delores L. Garcia, Mary L. Garcia, Anne L. Hansen, Carmel Lewis, and Emma L. Mitchell—have followed her example and become expert professional potters. Some two dozen granddaughters and great-granddaughters also pursue pottery-making careers.

Other families noted for excellent pottery are the Shutivas and the Chinos. The Shutivas, Ernest and Stella, produce high-quality pottery. Stella, granddaughter of Jesse Garcia (the still-active Ácoma potter), was invited by the Smithsonian Institution in 1973 to demonstrate her skills in Washington. Stella has studied research books and museum collections with the goal of combining a feeling of the past with contemporary design. To guide her, the Smithsonian presented her with a portfolio of photographs of yesteryear Ácoma pottery.

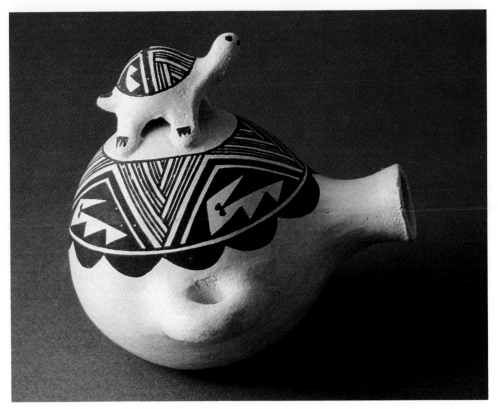

A modern Ácoma canteen is guarded by a ceramic turtle.

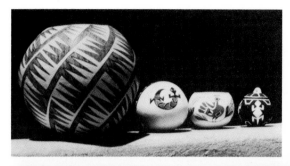

Left: *Contemporary products of Emma Lewis of Ácoma bear prehistoric Mimbres designs.*

Below: *Prized by collectors today are the specialties of Marie Z. Chino* (left) *and Emma Lewis* (right) *of Ácoma.*

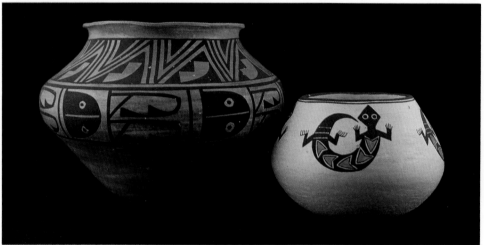

She fashions brushes from yucca leaves, grinds minerals for natural paints, and shapes her own sculpting tools. In Stella's studio is an item that helps explain the Puebloan grasp of the past: a stone, used to grind clay and paints, that has been in Stella's family since before the time of her great-great-grandmother, who died twenty-five years ago at age one hundred.

The late Marie Z. Chino was the matriarch of another noteworthy line of Ácoma potters. Her daughters, Rose, Carrie, and Grace, produce exquisite black-on-white, fine-lined Mimbres and Zuni deer designs on medium-sized ollas, bowls, and canteens. Third generation Chino potters are now acquiring reputations of their own.

LAGUNA

For those who are hopeful about southwestern Indian craft arts, the Laguna pueblo currently offers encouragement. After years of neglect, pottery making is being revived and may yet prosper.

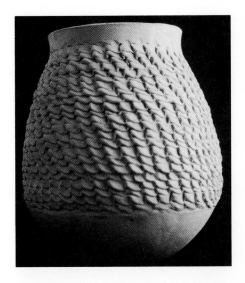

Incised texture on the surface of an Ácoma jar fashioned by Marie Chino echoes prehistoric southwestern pottery.

Of about five thousand Lagunas, three thousand live at the mother village or in summer farming camps and satellite villages scattered over a reservation of some four-hundred thousand acres. Laguna, founded by the Spaniards, was populated by individuals from a half-dozen other settlements. As at nearby Ácoma, Keresan is spoken.

Near the railroad and highway, and influenced by the diverse forces of the majority civilization, the people of Laguna abandoned many customs. They traveled, worked for wages, and embraced a variety of religions. Today, progressive Laguna derives income from uranium mines, an electronics plant, and recreation fees. Proceeds go to college scholarships for Laguna students and civic projects providing employment for village adults. The major casualty of acculturation was native crafts.

When Laguna pottery was made, it resembled Ácoma, although not quite so thin of wall and refined of design. The colors were much the same: kaolin for white, beeweed extract for black, and paint oxides that produce yellows, red, and brown when fired. In the early 1900s, good Laguna pottery was still being produced. Anthropologists and prescient private collectors gathered typical examples, some of which eventually went into safekeeping at institutions such as the Museum of Man at San Diego.

The all-too-familiar fate of so much Indian art overtook Laguna pottery in the middle of this century. Tourists would not pay prices sufficient to compensate pottery-makers for the long hours required for quality items. Rather, the market seemed to demand cheap junk adorned with arrows and swastikas; eventually, not even curios were worth the time involved.

Years grew into decades, and no excellent Laguna pottery was available. It was assumed that the skills for making pottery were lost in this pueblo. Yet one woman, Evelyn

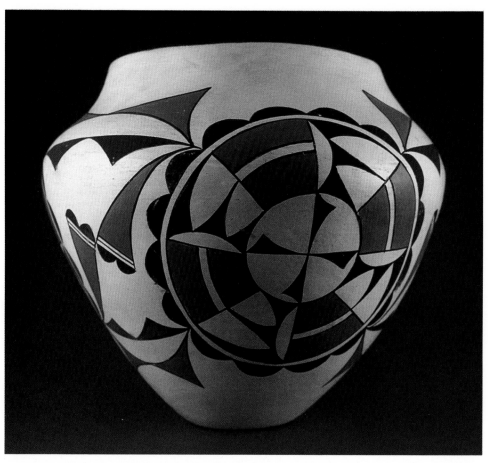

Although thoroughly subverted by tourist influence in the early 1900s, Laguna pottery today reaches into the past for legitimate designs.

Cheromiah, kept faith. Employing age-old techniques and styles, she continued to coil, smooth, paint, and fire ceramics for family and friends. In 1973, Nancy Winslow of Albuquerque visited Laguna, where she had lived as a girl, and was saddened by the disappearance of the pueblo's ceramics. On hearing of Mrs. Cheromiah's ability, Mrs. Winslow impulsively applied for a modest federal grant to finance classes that would be taught by Mrs. Cheromiah.

"To everyone's surprise, the grant was approved," recalls Mrs. Winslow. "Suddenly we had a budget, a teacher, enthusiastic students . . . and serious gaps in our knowledge of older

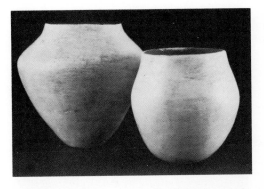

Subtle curves of today's Laguna ceramics derive from prehistoric pottery.

Laguna styles." The project found guidance in history. Most helpful were photographs provided by the Museum of Man of its pottery from Laguna/Ácoma. Color transparencies were projected onto a screen, and aspiring potters of Laguna could scrutinize the creations of their grandmothers.

Out of this cooperation grew a plan to invite Evelyn Cheromiah to southern California to spread the word of the regeneration of Laguna ceramic art. In autumn 1973, cars laden with eight thousand dollars worth of Pueblo pottery, clay, an iron grate, grinding stones, and twelve hundred pounds of dried cattle dung arrived at the Museum of Man, and for ten days Mrs. Cheromiah fashioned pots at a work station set up in the center of the main floor. The climax of the visit was the firing of freshly made pots, pueblo fashion, in the outdoor courtyard in front of the museum. Mrs. Cheromiah's husband Bill periodically spoke to the crowds who came to see her work.

Fine, intricate lines of a modern Laguna jar are applied freehand.

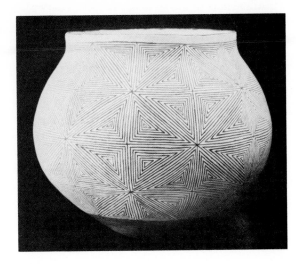

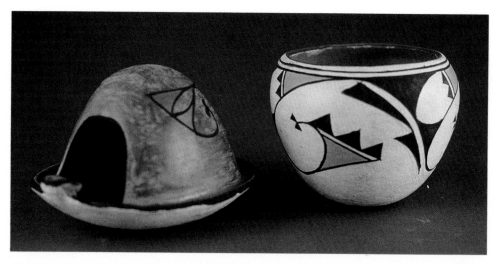

Revival pottery of Evelyn Cheromiah of Laguna.

Unworldly—she had never before seen the ocean—Mrs. Cheromiah, with her grace and serenity, charmed those attending a series of social events that were held in her honor in San Diego. Soon afterward, she was brought to Washington under the auspices of the Smithsonian. One day she went to the White House to meet President Nixon. The first lady asked for, and received, a pot from Mrs. Cheromiah. "She said she would put it inside the front door where everybody could see it," says Evelyn.

At the time of this writing, the prospects for Laguna ceramics are excellent. Several of Evelyn's students are actively creating quality pottery. Perhaps the most advanced are Lupé Cheromiah and Josephita Cheromiah (who are only distantly related to Evelyn). Others are steadily improving. No one yet has attained the expertise of the teacher, understandable, inasmuch as even in the old days, Pueblo girls did not learn pottery making quickly.

Traditional Laguna designs resemble those of Ácoma, both in geometric and figured styles. Hatch lines in some of Evelyn Cheromiah's ollas are less than one-sixteenth of an inch apart, calling for an extraordinarily steady hand. Most pieces now produced are medium-sized, a trend throughout the pueblos, but occasionally Laguna potters will risk making a jar as large as a pumpkin. Evelyn herself experiments: now a bowl, then a child's canteen, next a pert figurine of a turkey, then a miniature of a baking oven. She wins blue ribbons at Indian shows.

"I'm doing all right," says she. "I get around and try to become better known. People hear of me and they come to my house in Laguna, and I sell them some things. Sometimes I wonder if I'm wasting my time, but when I need courage, I remember those days in the museum when so many people said they liked what I was doing."

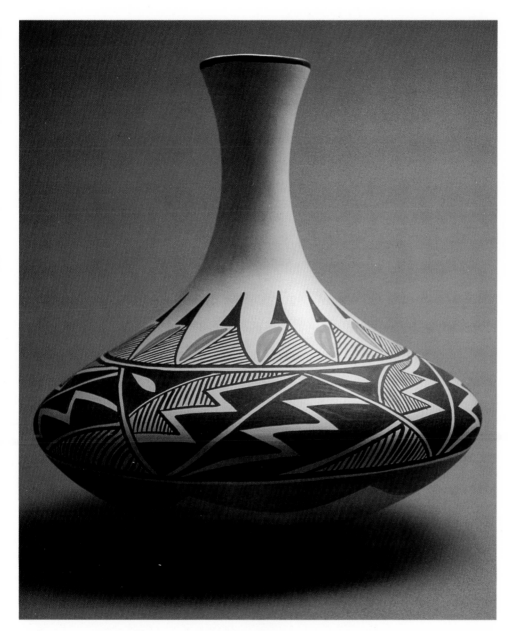

Isleta urn by Stella Teller, as graceful as the clouds that inspired it.

ISLETA

The Isleta pueblo can be likened to a great earthen vessel where human ingredients have mixed but not melted. Thirteen miles south of Albuquerque, Isleta and its suburbs bring together Tewa-speaking Puebloans, numerous descendants of Spanish colonists, and a neighborhood made up of people with a refugee-Laguna heritage. These Laguna women only recently revived a manufacture of a kind of pottery that has little association with the past.

Small bowls, ollas, and tall vases are smoothly formed, given a red pastel base, and covered above the midline with geometric designs in black and red on a stark white field. Some wares are glazed inside, but exteriors are left flat. Styles are reminiscent of old Zia.

SANTA ANA

The pueblo of Santa Ana, dating from 1700, is today virtually abandoned. It is left to caretakers, while some four hundred Santa Anans live on the Rio Grande near their farm fields. The pueblo, eight miles northwest of Bernalillo, is often closed to the public.

Among the women of Santa Ana, however, a hopeful revival in traditional pottery-making was led by Eudora Montoya, the last surviving Santa Ana potter. Bowls and ollas of steadily improving quality emerge from her students, notably Angie and Rose Armijo, Lena Garcia, Laura Paquin, and Bertie Pasquia.

The oldstyle wares are slipped with a grayish, impure kaolin and divided by heavy red

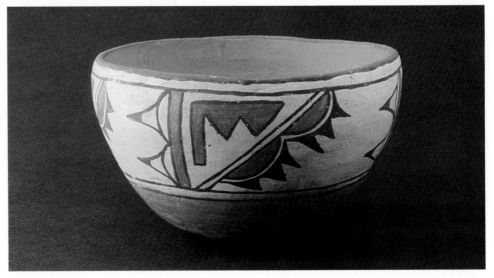

Among the very few items still produced at Santa Ana is this small bowl by Eudora Montoya.

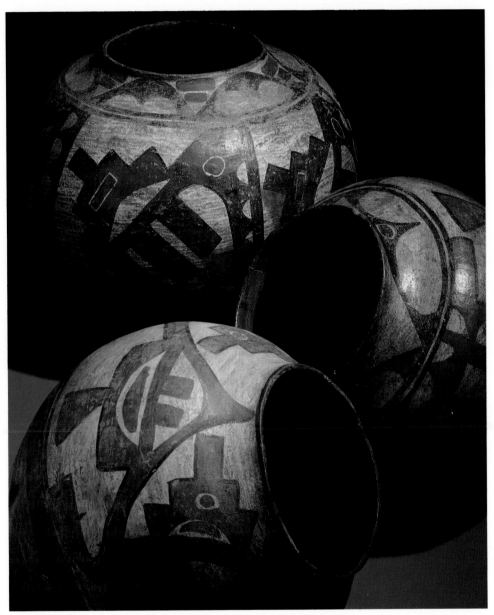

Santa Ana pottery, ca. early twentieth century, courtesy of The Heard Museum, Phoenix, Arizona.
Photograph by Jerry Jacka ©1985

designs outlined in dark brown. Walls of the students' pots are somewhat heavier than the walls of the pieces made by Mrs. Montoya. Retrieved from Mrs. Montoya's memory are classic Santa Ana symbols: turkey eyes, clouds, lightning, rainbows, *tablitas* (headdresses), and crosses. In all ways, the Santa Ana revival attempts to remain true to tradition. Clays are dug from pits used by their ancestors. The material is ground between stones. Sand is used as temper. Paints come from nature. The pottery is also fired as in olden times.

Modest grants from private sources provided the initial support for this revival, and it is to be hoped that it continues, fueled by the potters' artistic and financial successes.

ZIA

Sixteen miles northwest of Bernalillo, Zia pueblo perches on a mesa overlooking Jemez Creek. The village is one of the oldest in New Mexico, tracing its origins to 1300. At the time of Spanish contact, five Zia pueblos were home to about twenty-five hundred Keresan-speaking people. Today, fewer than four hundred of the five hundred Zias eke out a living on a ninety thousand-acre reservation that is chronically soil- and water-poor. Lingering resentment toward Zia by other pueblo groups stems from Zia's long history of loyalty to and alliance with the Spaniards; the record shows, however, that this collaboration followed a battle in which six hundred Zias were slain.

Old Zia ceramic wares were done with a white slip, but in recent times, the potters are using more buff. Bowls and tallish ollas are shaped in gentle curves, finely finished. Occasionally, a Zia potter is induced to make and fire a large storage jar, although the bulk of their work is of smaller dimension. Wide, undulating bands, often of the same brick red as the base, divide the bulging sides of jars; these bands separate the base from the design area. Bases are usually colored red, while rims may be left undecorated or at most, scribed with a single line or simple geometric band. Basalt, found in abundance at the pueblo, is ground into fine grains using a stone mano and metate; from these grains, black paint is created (this may be the same mineral used by some Jemez potters).

Long a style-setter in the region, Zia contributed its ancient pottery sun symbol to the design of the New Mexico state flag. Zia decorations of today, says collector John Barry, frequently include deer, bird, and floral designs in red and black on a creamy white background. The most popular are large-petalled, daisylike flowers and scrawny but lively stylized fowl. The notion may earn an argument in Zia, but some authorities hint that these designs might have been taken long ago from embroidery imported from Spain.

Zia potters have a reputation for steady hands, and many of them proudly sign their work. Production of these thick-walled, serviceable pots is high, but their quality is varied. Recently, one southwestern crafts center stocked more than one hundred Zia pieces, ranging in price from six dollars to six hundred dollars.

Active Zia potters include Seferina Bell, Candelaria Gachupin, Helen Gachupin, Elizabeth Medina, Sofia Medina, Juanita Pino, and Euseba Shije. Rafael and J. D. Medina have a distinctive, non-traditional style, decorated with acrylic painted designs. Their

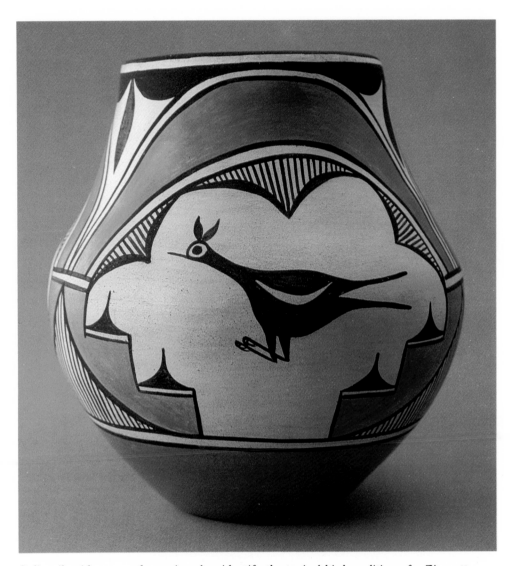

Split tail, wide eye, and grasping claw identify the typical bird rendition of a Zia potter.

Pueblo dancers and eagles are expressed in fine detail, using a multitude of colors. Their pottery has been featured in several major exhibits and seems to be accepted by the contemporary collector.

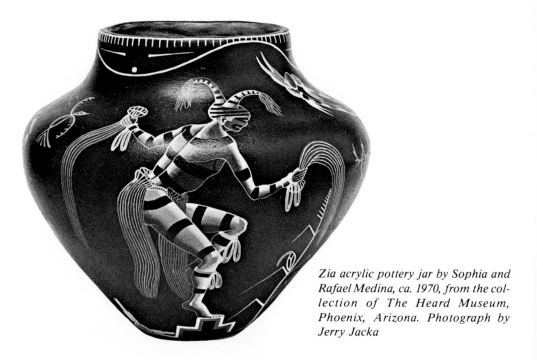

Zia acrylic pottery jar by Sophia and Rafael Medina, ca. 1970, from the collection of The Heard Museum, Phoenix, Arizona. Photograph by Jerry Jacka

SANTO DOMINGO

On the east bank of the Rio Grande, south of Cochití, Santo Domingo is reputed to be the most conservative of all the pueblos. Children may play with plastic toys, young girls may wear modish dress, and the men may drive pickup trucks, but beneath the veneer of the twentieth century, life is decidedly of another era.

Nearly all Santo Domingo people live on the sixty-six thousand-acre reservation. By Pueblo standards, the structures of the main village are not old, a flood having swept away much of the town in 1886. Farming and stock-raising are still the major occupations of Santo Domingo men. Supplemental income is derived from crafts, notably delicate necklaces of shell and turquoise. The habits of passive resistance toward outside rule remains strong at Santo Domingo. The native religious tradition is cherished, and although some ceremonies, such as the dramatic corn dance, are public, those who try to pry into the ritual secrets of the pueblo are resented.

As might be expected, restrained formality marks Santo Domingo pottery. If done in the old way, the jars and bowls are globular, and the basic slip is a bentonite so fine it polishes with a rag. Designs are geometric, with angles rounded off by masses of black. If birds and flowers are included, they are often enclosed by such geometric bands. More and more red is showing up in oldstyle Santo Domingo wares. To be avoided are the red and black shiny

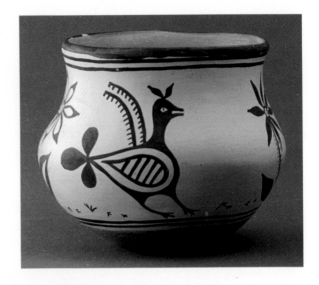

Earthen hues and stylized birds prevail in contemporary Santo Domingo pottery.

knickknacks daubed with brilliant house paints.

Among the better Santo Domingo potters is Rose Chama, who occasionally makes large ollas, dough bowls, or water jars. Also active are Cecelia M. Nieto and Robert Tenorio.

JEMEZ

Fifty miles west of Santa Fe, in the consolidated pueblo of Jemez, live the only group of people who still speak the Towa tongue. Before Spanish times, there were eleven villages around Agua Caliente, but through force, bad luck, and bribery, they experienced three centuries of village relocation, destruction, and rebuilding. The present village, home of about a thousand remnant Towa, dates from 1703.

Once Jemez was noted for its understated pottery: lovely bowls with red-brown bottoms and geometric and life designs done in soft colors against a muted ivory ground. Today, one has to pick through acres of small, brightly colored curios—including scenes from the Old World—to find anything traditional of clay in Jemez. When found, it is likely to be merely clay dried in the sun, unfired, and finished with paint from a can.

Talent exists in Jemez. Lenora Fragua shapes graceful bowls and wedding jars, and P. M. Gachupin turns out hollow, upright modeled owls that vibrate with wise spirits. Laura Gachupin, Marie Romero, Vangie Tofoya, Juanita Toledo, Maxine Toya, and Evelyn Vigil are among the better Jemez potters.

SAN FELIPE

Closely related to Cochití, the conservative pueblo of San Felipe was built on the west bank of the Rio Grande in the early 1700s. Despite a large resident population of more than one

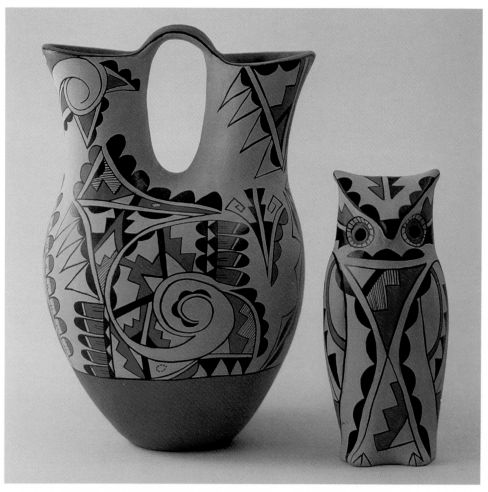

Jemez wares are often done in bright commercial paints, but some subdued pieces are appealing in shape and subject.

thousand, only a few potters are still active in San Felipe. The wares are heavy of base and wall. Basic patterns and colors are less elaborate but similar to those of Santo Domingo and Cochití. On a pink-gray bentonite slip, crude designs are painted in black. During firing, many pieces are marred by fire clouds. Humble though they may be, the wares of San Felipe are truer to Puebloan tradition than the more finely crafted but sun-dried and brightly colored clay curios made elsewhere for the tourist trade.

A faint shadow of a grander day, this modern San Felipe bowl is decorated with only a scrawny, clumsy bird.

COCHITÍ

Cochití, a pueblo dating from pre-Columbian times, lies some forty miles north of Albu-querque and is the northernmost Keresan settlement. About half of its citizens live at Cochití, while the remainder live away from the reservation, nearer to jobs and city conveniences. The history of the pueblo is a familiar litany of Spanish domination and Indian rebellion. The mood today, however, is harmony between people of Indian descent and those who trace lineage to Spanish-American colonists who sought refuge in Cochití from Navajo and Apache raiders before and after 1800.

A portion of the San Buenaventura Mission dates to 1694, and the Catholic faith has a strong following in this pueblo. At the same time, Cochitiños participate in a full schedule of native ceremonials, including kachina dances closed to the public. Of a variety of well-made crafts, Cochití is best known for its drums of hollowed logs stretched with rawhide, which are in great demand by other tribes.

Anthropologist H. P. Mera judged Cochití pottery making to be undistinguished. Styles were borrowed from Tewa neighbors, resulting in "a struggle for effect without understanding." Unrelated designs were mingled with random elements. But by the turn of this century, Cochití potters managed to bring some order and artistry to their ceramic crafts.

The typical Cochití pot has come to be considered a bowl with an incurving rim, or very

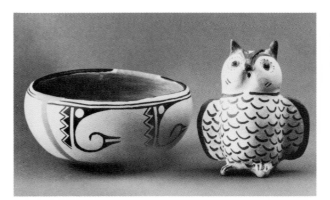

Earthen, pastel hues of Cochiti pottery contrast with lively figures, such as this upstanding, vocal owl.

short, wide neck. The pieces are imperfectly shaped, and the designs are casually applied. The overall slip of flat bentonite carries a pinkish cast. Conventionalized symbols of clouds, rain, lightning, and water often are drawn in beeweed black around the rims. Most bowls boast red bases, and partially filling the main field may be more thunderstorms, which are sometimes alternated with birds that look as if they flew backward through a dust storm. The horizontal lines customarily are broken to form a "spirit path," so that the soul of the pot is not entrapped.

Cochití potters also model an array of figurines, a Cochití tradition for at least two centuries. Terecita Romero, at eighty years of age living in well-deserved retirement, won wide praise for her diminutive animal figures, representing creatures of her homeland and of other continents. (She was also not above contriving her own personal interpretations of dinosaurs.) Cochití potters today include Juanita Arquero, Maggie Chalan, Virginia Naranjo, Serefina Ortiz, Ada Suina, Frances Suina, and Dorothy Trujillo. And, in an odd twist, Cochití's best-known active ceramist is a woman who claims that she was a failure as a maker of pots. Says Helen Cordero, "Juanita Arquero, my husband's cousin, tried to teach me to do pots and bowls, but I couldn't learn. But figurines? When I did them, I thought maybe that's what I was made for, because they make people happy."

True enough, people of all ethnic backgrounds are amused by Helen's sculptures of the people she sees within her pueblo. Her nativity assemblage has fifteen pieces and sells for several thousand dollars. Other modelings are of Story Teller (a grandmother with children clinging to her shoulders and filling her lap), Drummer, Singing Mother, Water Carrier, and Pueblo Father. Demand for her work is such that, at Indian shows, Helen Cordero sells out her stock as fast as she can unwrap it. Yet with characteristic Puebloan modesty, in a newspaper interview, she denied that she herself has changed.

Helen was quoted as saying, "I'm not famous. I don't think I should be. I'm just happy because people are happy with what I do. And I haven't changed. I still like to visit with people who come to the pueblo to visit me. I like to meet who's who, and chat."

Ten miles north of Santa Fe, the people of Tesuque pueblo cling to the religion, ceremonies, and Tewa language of their forebears. At the same time, the potters among these one hundred and forty souls mass-produce a clay product without historic derivation. Why Tesuque is so old-fashioned in philosophy and at the same time so cynical in crafts is something of a mystery. Perhaps instead of singing, Tesuque clay laughs . . . at the Anglos.

Once, Tesuque potters made globular jars and finished them in styles similar to the wares of Cochití. Tesuque black-on-cream had a bentonite slip, painted with black lines in continuous and angular designs, or in figures from nature. The pottery was unmistakably Puebloan.

Around 1920, Tesuque potters turned almost exclusively to the manufacture of tourist bric-a-brac tinted with commercial poster paint in psychedelic shades never seen before on Pueblo pottery. Chartreuse, purple, and pink illuminated the outpouring of sun-dried knick-knacks from Tesuque, that is, until the unfired watercolors wore away. Some Tesuque designs do relate to old styles, but this virtue is offset by counterfeit forms. "The most infamous of these," wrote the late Tom Bahti, an anthropologist with strong sympathies for the Indian, "is the so-called Tesuque Rain God, originally produced as a giveaway for a midwestern candy manufacturer. Probably patterned after a figurine from Old Mexico, it has no connection with Tesuque, rain, or gods. It is still being made and sold today— which goes to prove Mencken was right when he said that 'no one ever lost a dime by underestimating the bad taste of the American public.' "

In recent times, items with traditional feeling have been done by Anna Maria Lovato, Lorencita Pino, Sorenata Pino, Manuel Vigil, and Priscilla Vigil, but such pieces are rare.

Modern Tesuque jar is finished in poster paint.

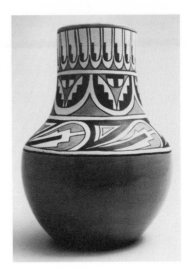

Tesuque jar by Lorencita Pino, courtesy of Richard M. Howard. Photograph by Jerry Jacka ©1985

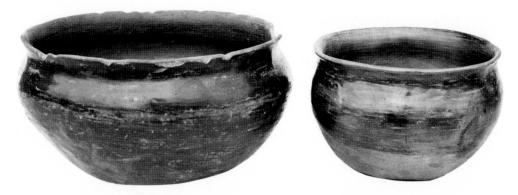

Two vessels created by Josefita Anaya ca. 1920, 1950, showing the last of the Nambe pottery styles. Museum of New Mexico

NAMBE AND POJOAQUE

Although bracketed by the dominant ceramic centers of San Ildefonso and Santa Clara, the neighboring settlements of Nambe and Pojoaque persist today more as legal reservations than as active pueblos. Splendid polychrome pottery was distinctive to these place names long ago, and into the 1940s, Nambe women fired micaceous vessels similar to those currently produced in Taos and Picurís. But now, of the several hundred individuals holding vested reservation rights, only about half are residents.

Within the name Virginia Gutierrez reposes much of the flinty determination symbolized by the smallish ceramic production from Nambe-Pojoaque today. Born in 1941, tutored by an aunt, Mrs. Gutierrez would not stray from true ways: native clays from Nambe; an old formula processing a mixture of clay and sand; hand-coiling, -shaping, and -burnishing; natural clay paints; intricately wrought designs of kachinas, sun faces, bear claws, animals, and abstractions; then the shape of seed jars and vases fired two, three, even five times to ensure proper colors. Only a few other potters approach the virtuosity of Virginia Gutierrez in Nambe during the 1980s, among them Joseph and Thelma Talachy.

SAN ILDEFONSO

Pride, passion, self-esteem, money, competition, acclaim. These are the driving forces of artists the world around, and in full measure they are the motivations of the people of the pueblo given most credit for the current renaissance in artistic southwestern pottery. Witnessing the outpouring of masterworks from San Ildefonso today, it is difficult to comprehend that only two generations ago, the potters of this pueblo were preoccupied with erstaz designs and tourist gimcracks.

As do other Tewa-speaking pueblos, San Ildefonso derives from prehistoric villages of

59

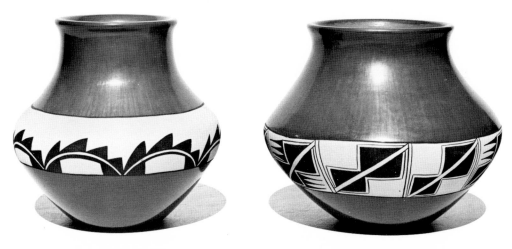

Jars ca. 1975 by Joe and Thelma Talachy of Pojoaque. Museum of New Mexico

the Pajarito Plateau. The people became valley dwellers in about 1300, changing village sites from time to time because of troubles with the Spaniards and internal quarreling. The division of the pueblo into two plazas stems from disagreements that have, in recent times, been resolved. Now a close-knit community, San Ildefonso is but a short distance north of Santa Fe.

Modern San Ildefonsans insist that shiny blackware was always made in the pueblo, but science holds other views. In 1938, anthropologist H. P. Mera wrote,

> Unlike the pottery of the western pueblos and some of its neighbors to the south, the wares ancestral to those of San Ildefonso were never affected by the great spread of glaze paint decorations which, in its day, dominated so large a part of the Southwest. Instead, there was in this region an uninterrupted succession of pottery types based on black-on-white wares which extended over a period of some several hundred years.

According to another anthropologist, Clara Lee Tanner,

> The older wares produced at San Ildefonso were of three styles: black-on-red, black-on-cream, and black and red-on-white (or cream) ground. In the polychrome wares, red was used sparingly. Whereas the clay in the modern black ware is coarse and porous, and the walls are thick, the earlier vessels were produced of better clays and were thinner walled. Smooth walls were and are typical of San Ildefonso pottery.

Just when San Ildefonso took up the manufacture of burnished pottery is open to discussion, but at any rate, the earlier examples were plain.

The late María Martinez was probably the most visible and renowned of those San Ildefonsan potters who created burnished, black-on-black wares. She was taught to make ceramics during the 1890s by Tia Nicolasa, her aunt. At nineteen, María married Julian Martinez, a teacher at the pueblo's school, and with federal sponsorship, they spent a four-month honeymoon at the St. Louis World's Fair, where Indians of many tribes gathered to demonstrate ceremonies and crafts. Marie (the spelling she would prefer for half a century) steadily sharpened her skills.

Why did she make black pottery? Who conceived of painting matte designs on polished

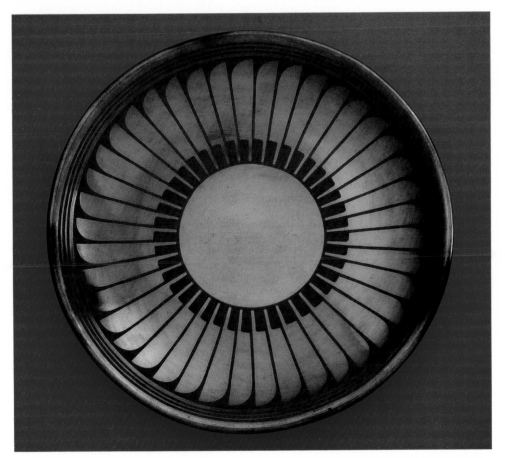

Matte/polished plate by Maria/Popovi, with feather design. Photograph by Jerry Jacka ©1985

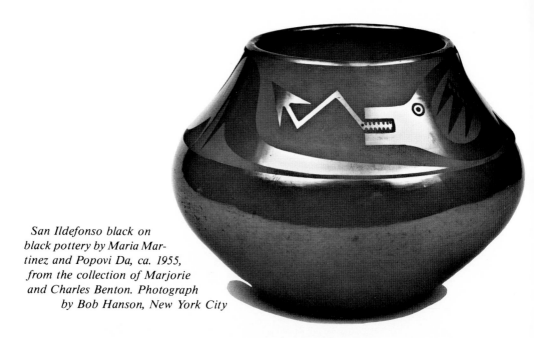

San Ildefonso black on black pottery by Maria Martinez and Popovi Da, ca. 1955, from the collection of Marjorie and Charles Benton. Photograph by Bob Hanson, New York City

pottery? Was Julian the inventor of the process for turning red pottery black in firing? María's biographer, Alice Marriott, stated that Julian hit upon the method of firing black pottery by accident. From a standard burn, two pieces emerged black. Julian's curiosity led to the practice of smothering the fire with pulverized manure; the carbon in the heavy smoke settled on the pottery and permanently colored it. As for the origin of the combination matte/polished design, Marriott's version has Julian impulsively painting a design on one of his wife's shiny pots; after firing, the Martinezes were delighted with the result: black matte design on a glowing black background. Anthropologist Kenneth M. Chapman ascribes a more gradual evolution of the matte/polished style: the first matte bowls were washed all over, and the design was brought out by burnishing only that portion of the piece. In tidying up the outline of the design, Julian had to use a brush dipped in slip.

In a logical next step, "Julian improved the design by confining the *avanyu* (rain serpent) to a band in which relatively little matte was needed. The *avanyu* and the feather design are the two outstanding examples of Julian's motifs developed in the matte itself, from simple to more complex."

Chroniclers agree that it was 1919 when María and Julian established what was to be their landmark style. Their fame spread and their wares came into demand nationwide. Having blazed a path to economic freedom, they gave heart to the artists of their pueblo and other villages. They generously shared their secrets with their neighbors, and when traveling, strived for recognition of their people as well as themselves.

Their composition of masterpiece pottery continued until Julian's death in February 1944; thereafter, María made no pottery for eight years. When she once again began crafting ceramics, she worked by herself and with her daughter-in-law Santana and her son Popovi. In 1971, at age eighty-six, with dimmed sight and feeble hand, María polished the last of her pots—slightly out of round and flawed, but still magnificent. She died in her sleep, a world figure, on July 21, 1980.

So monumental were María's triumphs that they remain as challenges to San Ildefonso potters. A yeasty atmosphere of innovation permeates the art circles of San Ildefonso, not only in pottery but in painting and jewelry as well. Following the lead of Rosalie Aguilar, potters of the pueblo carve exquisite designs into their wares. Figurines have grown into large, symbol-charged, ceramic fetishes, such as turtles bearing accessories of beads and turquoise, done by Tony Da, a grandson of María and Julian. Some of the oldstyle black-on-red and polychrome wares are also being made. The pots of Adam Martinez and his wife Santana command premium prices as well.

While lists of premier potters are subjective, and can be unfair by omission, it is safe to say that Rose Gonzales has never created better bowls and ollas that she does now, and she is invited everywhere. Barbara Gonzales and Juan Tafoya are other favorites. Clara Tanner

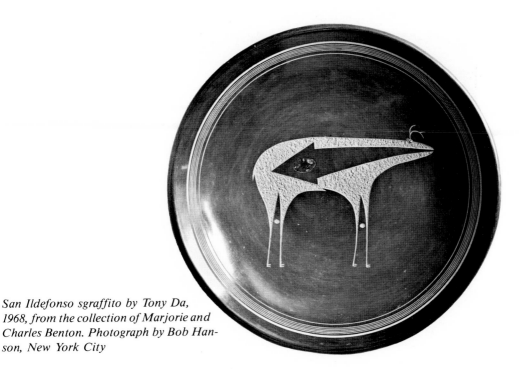

San Ildefonso sgraffito by Tony Da, 1968, from the collection of Marjorie and Charles Benton. Photograph by Bob Hanson, New York City

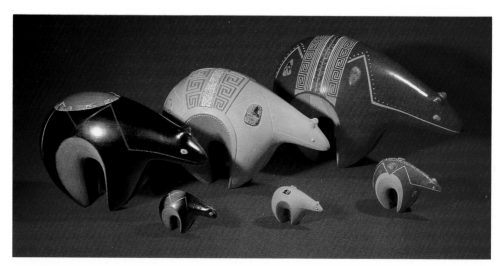

Tony Da's pottery bears. Photograph by Jerry Jacka ©1985

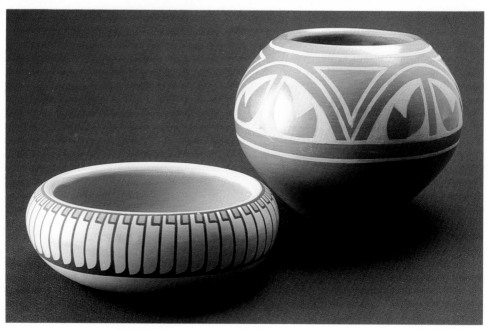

Polychrome gems from modern San Ildefonso include the familiar feather motif (foreground).

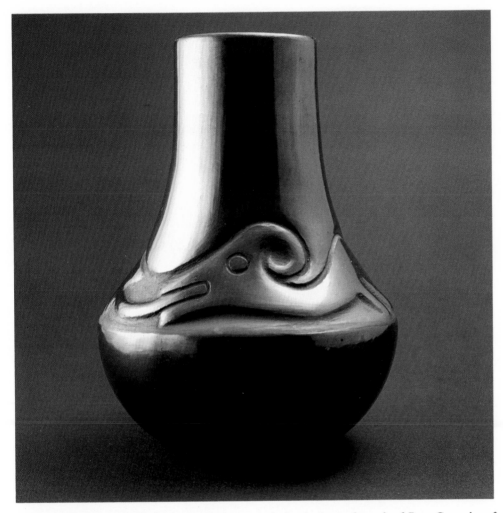

A long-necked jar with an incised water serpent design is the trademark of Rose Gonzales of San Ildefonso.

would add Rose Cata, Blue Corn, Juanita Gonzales, Lupita Martinez, and Desideria Sanchez. Blue Corn is noted for her matte feather motifs on an unusual gray-buff ground, as well as for polished black and red ware. Other San Ildefonso potters include Isabel Atencio; Carlos Dunlap and his daughter, Charlotte; Helen Gutierrez; Margaret Lou Gutierrez; Anita Martinez; Clara Montoya; Anita Pino; Angelita Sanchez; Tse-pe (Juan Gonzales); Dora Tse-pe; and Albert, Josephine, Doug, and Charlotte Vigil.

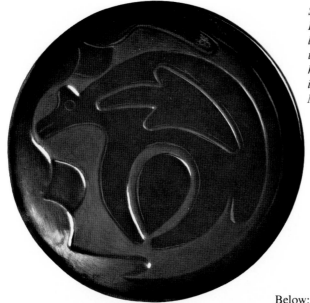

San Ildefonso carved black plate by Rose Gonzales, ca. 1974, from the collection of Marjorie and Charles Benton. The artist has created an unusual heartline design with a bear paw motif in relief. Photograph by Bob Hanson, New York City

Below: *Detail from a bowl made in 1972: Tse-pe of San Ildefonso incised a bison figure into the burnished surface.*

If southwestern Indian pottery were displayed and sold only in museums and shops, the treasures would be as anonymous as coins. The extra dimension in acquiring a collection of Pueblo pottery is to become acquainted with the artists, their ways of life, and their rich heritage. No pueblo offers greater opportunity for this sort of rapport than Santa Clara, two miles south of Española. The residents are friendly and courteous toward well-mannered and interested visitors.

The Santa Clara people care for Puyé, located about twelve miles from the pueblo and thought to be their ancestral home. It was the first Rio Grande Valley ruin to be excavated by scientific system. Within and around Puyé's honeycomb rooms (dated by the tree-ring calendar from the late 1200s to the middle 1500s), archaeologists recovered splendid pottery. These wares were most frequently decorated by the *avanyu*, or plumed serpent, who in Tewa lore guards the springs, lakes, and rivers so crucial to life in the arid Southwest.

Puyé thrived when the pueblo of Santa Clara was founded in the fourteenth century. Santa Clarans suffered through the centuries of conquest, rebellion, and cultural change of European civilization, somehow retaining their ceramic birthright. Into the 1900s, they continued to fashion highly polished black and red wares in distinctive forms. One shape was the so-called wedding jar, whose bulbous body grew into two graceful, tall spouts joined by a flat handle. Another shape was a wide-bodied jar with a constricted neck that was emphasized by a ring of clay.

In oldstyle Santa Clara pottery, simple designs, such as slanting melon stripes or five-digit bear paws, were pressed into the clay while it was still soft. According to a legend retold by collector Clark Field in 1970,

during a year of extreme drouth, the springs and the rivers were dry, and the pueblo was desperate for water. The Santa Clara villagers feared they would die of thirst. The *cacique*, or a medicine man, went up into the mountains to pray to God the Creator to save his people from dying of thirst. While there, he saw a bear. He realized the bear must have water to live and followed him all day. At evening, the bear went to a spring. The medicine man rushed back to his village, and all the people strong enough to carry water jars went up into the mountains to the spring and carried water back to the village.

The first thing they did when they arrived at the village was to go to their kiva (underground meeting place) and hold a thanksgiving service, thanking the Creator for saving them from dying of thirst.

So that they would not forget the blessing, they took a vow that henceforth the bear's-paw design would be put on pottery. That custom has prevailed for more than four hundred years. All other Indian villages respect the traditional Santa Clara design of the bear's paw and do not duplicate the design on their own pottery.

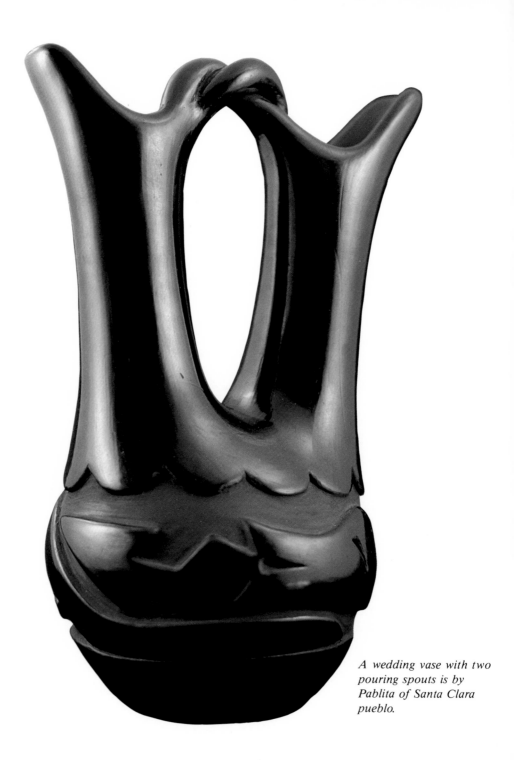

A wedding vase with two pouring spouts is by Pablita of Santa Clara pueblo.

Through the 1930s, Santa Clara potters conceived a variety of innovations. They made burnished black and matte/polished items similar to those of nearby San Ildefonso. They modeled quaint animal figurines. They painted their polished red wares in geometric designs with matte colors: white, cream, tan, red. In recent years, the idea of depressed design was extended to precise carving (often of the rain serpent or some other ancient symbol). One style is burnished black, with depressed areas dulled by matte black. In another Santa Clara style, the carved areas in burnished red are accented by cream-colored paint.

Today, of the five hundred fifty residents of Santa Clara, about two hundred are pottery makers, among them some of the more famous and high-priced artists of the West. Some of their work honors the old disciplines, but many young potters treat clay as a medium for imaginative expression, with only a token reference made to tradition.

Representing a more conservative school are the works of Legoria, born in Santa Clara in 1911. Married while very young to Pasqual Tafoya, Legoria soon had four children of countless needs. As a way of augmenting family income, she learned to make figurines from her grandmother. Through the ensuing years, Legoria won a trunkful of ribbons and prizes for her wedding jars, ollas, and candle holders. Her symbols are from the past: terraced

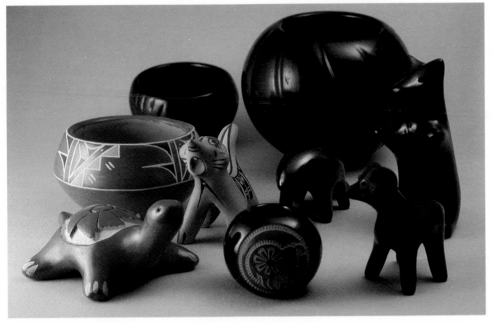

A veritable zoo of figurines accompanies the more mundane shapes of today's Santa Clara pottery.

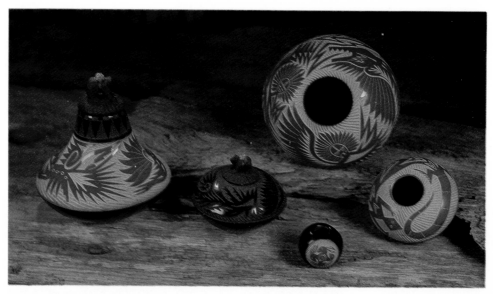

Pottery by Joseph Lonewolf. Photograph by Jerry Jacka ©1985

horizon, sky abstractions, plumed serpent, and bear paw. Documentary motion pictures of Legoria's techniques were filmed by the National Park Service and by the University of Ohio.

Among the better-known younger potters of Santa Clara is Joseph Lonewolf, who was born about the time Legoria was learning to make pottery. Son of a distinguished male potter, Camilio Tafoya (Sunflower), Lonewolf began forming clay when he was a small boy. At present, the greatest acceptance has been of his jewel-like miniatures, crisply incised with designs from the prehistoric Mimbres. His awards are beyond enumeration.

Lonewolf says he did not become a full-time potter until the spring of 1972. Before then, he worked as a journeyman mechanic; he had also tried his hand at refinishing antiques, carpentry, tanning skins, and silversmithing. Within six months after taking up ceramics as a career, Lonewolf presented a major show. His pots were as small as golf balls and as large as bowling balls. All were black, with white designs incised into colored medallions. By what Lonewolf claims is a secret process, he obtains black and the second color with a single slip fired only once. "People tell me I did something brand new," he says. "I've just figured out all over again what potters did centuries ago." Lonewolf's sale was mobbed by buyers who were eager to pay as much as three thousand dollars for one pot. In recent times, Lonewolf has struck off into new directions: bas-relief, corrugation, pale gray coloration, terra-cotta. But he is reluctant to talk of future works, explaining that "I believe the clay is a

living thing, and Mother Earth, a living thing. Without her, we'd not have food or plants or animals."

"I talk to her before I take clay from her. And I believe that the clay has feelings. I hurt the clay's feelings when I talk of a pot that hasn't been done yet, and the clay talks back by breaking or cracking. So I have learned to respect its feelings and never talk of a pot until it is completed, finished and ready to talk for itself." Of his design elements, he says, "I regard the Mimbres as my ancestors. Though I refine their designs, each design must have a meaning for me. In my dreams, I see the design, how to make the pot happen. Then when I work the clay, everything flows."

Today, Lonewolf is among the best-known of six generations of Tafoya family potters

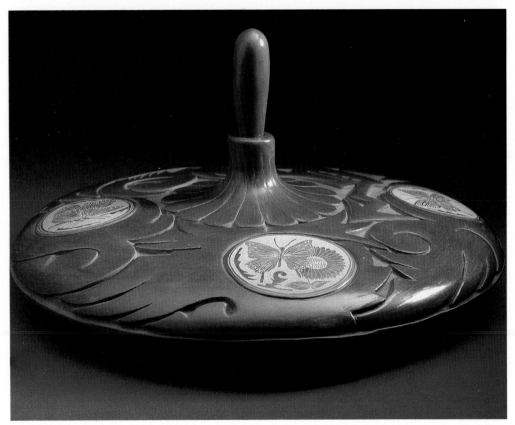

Elegant example of incised Santa Clara pottery, created by Grace Medicine Flower. Photograph by Jerry Jacka ©1985

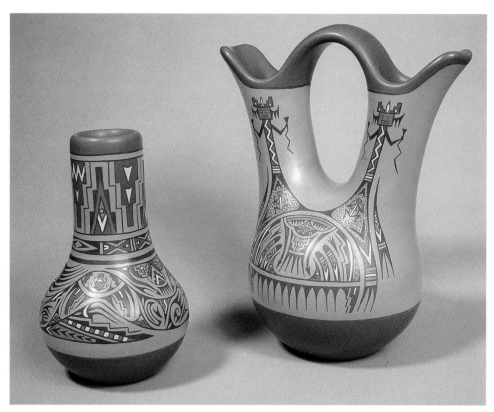

Polychrome pottery by Margaret and Luther of Santa Clara. Photograph by Jerry Jacka ©1985

(the matriarch, Margaret Tafoya, gave eight daughters to the craft and in turn, their children are active potters). Another gifted Santa Clara potter is Lonewolf's sister, Grace Medicine Flower. Other potters of earned acclaim are Mary Archuleta; Mary Esther Archuleta; Angel Baca; Stella Chaverria; Nancy Cutler; Gloria Garcia (Goldenrod); Lela Gutierrez, Lois, Petra, and Pula Gutierrez; Christina Naranjo; Flora Naranjo; Madeline Naranjo; Teresita Naranjo; Tonita Roller; Susan Romero (Snowflake); Frances Salazar; Helen Shupla; Rosemary Speckled Rock (Apple Blossom); Paul Speckled Rock; Clara Suazo; Santanita Suazo; Lee Tafoya; Lu Ann Tafoya; Margaret Tafoya; Shirley Tafoya; Thelma Talachy; Lula Tapia; Helen Tapia; Jennie Trammel; Minnie Vigil; Mela Youngblood (Yellow Mistletoe); and Nathan Youngblood. Virginia Ebelacker today fashions and wins awards with her large, burnished black storage jars. The works of a team of Santa Clarans, Margaret and Luther, are washed in buff and tinted with pastels. Their whimsical skunks may sell for

one hundred dollars, but their bowls are often priced much higher.

Will these values hold up in the future? Are they justified today? As with bread, gasoline, and gold, pottery is worth what people are willing to pay. If a sketch dashed off in thirty seconds by Picasso can command one thousand dollars, why not a pot contrived in a week by Grace Medicine Flower? Obviously, at these prices, pottery making at Santa Clara will continue for a long time to come.

SAN JUAN

The largest of the Tewa-speaking pueblos, this community has been inhabited for nearly seven hundred years. It is here that the first Spanish capital was established in 1598, and from here that the medicine man Popé led the Pueblo Rebellion of 1680 that drove the European colonists temporarily from the Rio Grande Valley.

The pueblo is about five miles north of Española on the east bank of the Rio Grande. Because of a scarcity of work, about half of the thirteen hundred San Juan tribal members live away from the reservation. Social problems are aggravated for the young, who have little voice in their government.

San Juan has long been noted for polished redware. On some pieces, the slip is shined only in the upper portion; the lower section is left dull. A smaller amount is done in a similar way in black. Older forms are deep open bowls and roundish, short-necked jars. The San Juan double-spouted wedding vase resembles those of other pueblos. Until about 1930, the only decoration was little lumps of clay.

Beginning in the 1930s, Regina Cata and other San Juan potters drew inspiration from ancient pottery unearthed in nearby ruins. The women use a short pointed tool to incise their unfired pots. In one dominant contemporary style, the upper and lower bands of a piece are slipped in red and burnished. A large middle area carries designs incised into clay naturally flecked with bits of mica. The scratched designs usually fill the unslipped area with straight-line hatching, frets, slants, rectangles, and chevrons. Jars for this treatment are often bulbous; they are made with or without short necks. Bowls are also incised, and some are as flat as dinner plates, a most difficult form to survive firing uncracked. The pot's mellow luster may be enhanced by application of animal fat and a second firing.

In another innovative San Juan style, a jar is given an angular, bulging waistline. The rim of the jar and the portion below the waist is slipped with red and burnished. Above the waist, geometric designs are incised and matte colors then are painted on to fill the spaces between the incised lines. Pleasing to many are the muted matte pastels that speak of plateau panoramas: sand, tan, brick-red, lime-white, gray. Shallow bowls frequently are finished with polychrome, incised designs of simplified kachina masks.

Tomacita Montoya, long recognized as a premier San Juan potter, collaborated for some years with Dominguita Sisneros, and both names can be found on their wares. Other accomplished San Juan potters of the past decade include Rosita Cata, Rosita de Herrera, and Leonidas Tapia. Though continuation of pottery making at San Juan seems assured, the

Behind a more commonplace San Juan bowl is a difficult-to-find incised plate.

direction is uncertain. Bright commercial paints overstate designs that began with muted hues, and some of today's incising is carelessly done.

PICURÍS

Sharing Tewa ancestry with Taos, twenty miles to the north, the one hundred residents of Picurís show two faces to the world. One is poverty. The other is flawless hospitality. Picurís pueblo, founded about 1250, once harbored three thousand Indians. But too many young men went off to war, and years of exile on the Kansas plains were dogged by disease and more conflict. Nor have modern times been good. Chronic unemployment and underemployment blight many families of Picurís.

Yet no queen of court ever welcomed a stranger to her home more grandly than elderly

74

Picuris bean pot and bowl by Virginia Duran.

Virginia Duran. While her guest sits at a table protected by oilcloth, she arranges her inventory: a slant-sided bowl, a small jar, a larger bean pot. Glistening golden with bits of mica, fired flint-hard, they ring like crystal when Mrs. Duran thumps them. Are they similar to Taos pots?

A pained expression crosses the round, lined face of Mrs. Duran. "No," she says. Picurís pots are thinner of wall, lighter of color, and harder fired. "And they make things taste better," she insists. From her own refrigerator, she fetches pots of beans and chili to prove her point. Who could argue with such a confident artisan?

TAOS

The pueblo called Taos, as distinguished from the artsy-craftsy town, lies some sixty-five miles north of Santa Fe. On the rim of Spanish influence, old Taos was buffeted by forces from all sides; thus, it is the only walled pueblo. Today's village, with its pueblos of five stories and a photogenic church, dates to about 1700. An older village nearby was destroyed by fire.

From 1540 to the middle of this century, the people of Taos experienced conquest, rebellion, flight, exile, and resettlement. As late as 1910, American troops occupied Taos to

Of natural micaceous clay, a humble Taos bean pot serves its role as well as any modern vessel of metal or porcelain.

quell a threatened uprising, and internal disputes afterward sapped the people's strength. At present, some nine hundred Puebloans occupy several villages on the forty-seven thousand acre reservation.

Through its long history as a border town of Spanish-colonial America, Taos served as a trading post for the Jicarilla Apache, Comanche, Ute, and Navajo Indians. Many of the pueblo's customs of dress and ceremony are related to those of the Plains Indians. Not surprisingly, crafts, including pottery, tell of neighboring Athabaskan Indians.

Like Navajo wares, the pots of Taos are upstanding and utilitarian. The clay is rich with mica, which takes the place of temper and lends unslipped surfaces a golden, flecked sheen. Bean pots, pitchers, and dishes are hard-fired, and sometimes mottled by dark fire clouds. Another Navajo-Apache touch is roped lumps of clay sometimes added around rims for decoration. Modern wares, especially the useful bean pot, are equipped with handles and lids. Figurines are infrequently made.

Names to look for in Taos pottery are Alma L. Concha, Margaret Lujan, Virginia Ramirez, Paula Romero, and Virginia T. Romero.

At this writing, reports of revivals of more or less traditional ceramic wares come and go in the popular press and occasionally appear in native American arts and crafts journals. How much of this is built upon hope? What are realistic prospects? The temptation to dismiss them all as harmless optimism is dashed by some of the success stories from which this narrative is drawn. At moments, other refined traditions have clawed back from the brink of oblivion to enrich multiplying generations of potters. It is to be hoped that the contemporary pottery of the Southwest maintains its foothold in the twentieth century, and continues to share its grace and beauty with the rest of the world.

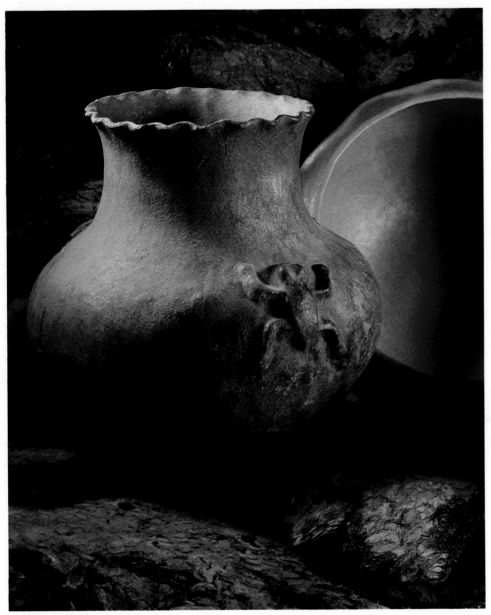

Pottery from Taos (left) *and Tesuque* (right), *courtesy of The Heard Museum, Phoenix, Arizona. Photograph by Jerry Jacka* ©1985

Notes on Finding and Keeping
a Worthwhile Pot

I AM ALWAYS THINKING ABOUT DESIGNS, even when I am doing other things. . . . I often dream of designs, and whenever I am ready to paint, I close my eyes and then the designs just come to me. I paint them as I see them. Ruth Bunzel, *The Pueblo Potter*

It is a wilderness of sunbaked stone, gray caliche, wind-cut clay red as barn paint, great bluish outcroppings of shale, the pockmarked dingy white of old volcanic ash and the cracked expanse of salt flats where the mud formed by the "male rains" of summer tastes as bitter as alum. . . . It is a landscape totally without hospitality, offering neither food, nor shade, nor water. The white mapmaker would call it Desolation Flats. "Our name for this," says Etcitty, "is Beautiful Valley." Tony Hillerman, "Dinehtah, If I Forget You . . ." *Arizona Highways Magazine*

With immediate apologies for the stereotyping (some Indians think like Lee Iacocca and some like Mother Teresa), if one presumes to acquire and care for an object flowing from Indian thought, it pays to think a little like an Indian. Publications from *Wassaja* to the *Navajo Times* unceasingly open pages to Indians philosophizing about Indianism. In a nutshell, recurring themes mention oneness with nature; a world of diverse levels of reality and ranks of power; a concept of time more like a floating bubble than a straight line; a perception of individuals unified in all aspects; and, quite frankly, assumptions of ethnic uniqueness—many an Indian tribal name means in English "the People." They may have a point; as Anglo cowboys allow in Arizona, "If you think all men are born equal, you ain't never met a Navajo riding a good horse."

FINDING A POT

So off to hunting a pot. The first and most emphatic rule: do not attempt to find one in the wild and dig it up. In an earlier, more profligate, and less sensitive investigation of historic America, pothunting was not only allowed but encouraged for amateurs and uncredentialed experts. But today, such practice violates federal, state, and local laws, and penalties can be severe. Ethical as well as legal logic argue against the disturbance of a prehistoric site even so small as a surface scatter of potsherds. The number of ancient sites is limited; in many instances, these sites represent the only available piece of a complex record of humankind; destruction by aimless diggers diminishes not only the achievements of the Early Ones, but robs us all of information.

The day may be past when the author, constrained within a budget of two thousand dollars, was able to assemble a traveling museum exhibit containing at least one example from every pottery-making tribe or distinct Arizona and New Mexico pueblo. That exhibit, sponsored by Exxon Company, USA, of Houston, Texas, ranged from an eight-dollar Zuni owl to a four-hundred dollar San Ildefonso sgraffiti bowl inlaid with turquoise. On average, the items retailed at sixty dollars each in 1972.

Even today, though, it is possible to obtain a worthy keepsake for less than that 1972 average price from a reputable dealer or institution shop or directly from a potter. But whatever the price, buy what you like and believe that you will cherish tomorrow. Seek out a reputable, established trader, or ask around for an area's outstanding museum shop. Get a receipt that describes your purchase; i.e., "an eight-inch-high polychrome jar, authentic Santa Clara Pueblo, by Lois Gutierrez," and the date and price.

Symmetry is desirable; globular bowls, jars, vases, and plates that are thrown so easily and perfectly on wheels are given uniformity of shape by southwestern potters (who do not use a wheel) at considerable investments of time and skill. Good pottery is to be felt as well as seen. Many thin-walled wares ring like bells when gently struck. If a vessel does not, there may be a hidden crack. And increasingly, better potters sign their wares with a name or mark, which, when authentic, may ensure an item's resale value.

WHERE TO BUY

A typical year in the Indian country of the American Southwest swings as regularly as the stars, with a variety of craft shows, exhibits, and ceremonials. To verify dates in New Mexico, a dependable calendar is kept by the Commission on Indian Affairs, Room 111, La Posada Inn, 330 East Palace Avenue, Santa Fe, NM 87501. For an accounting of Arizona dates, a preferred source is the Heard Museum, 22 East Monte Vista Road, Phoenix, AZ 85004. A comprehensive national calendar of museum exhibits and galleries dealing with Indian materials is kept by the quarterly publication, *American Indian Art Magazine*, 7314 East Osborn Drive, Scottsdale, AZ 85251. This publication regularly presents a listing of recommended (although certainly not all) activities. In the Southwest, museum shops of proven reliability include those of the Colorado River Indian Tribes Museum, Parker, Arizona; the Denver Museum of Natural History, Denver, Colorado; the Gila River Arts and Crafts Center near Sacaton, Arizona; the Hopi Arts and Crafts Cooperative, Second Mesa, Arizona; the Institute of American Indian Arts Museum, Santa Fe, New Mexico; the Museum of Northern Arizona, Flagstaff, Arizona; the Navajo Arts and Crafts Enterprise, Window Rock, Arizona; the Northern Pueblo Indian Artisans Guild, San Juan Pueblo, New Mexico; the Pueblo Cultural Center, Albuquerque, New Mexico; and the San Diego Museum of Man, San Diego, California. And, of course, in Phoenix, Arizona, the museum shop at the Heard Museum.

In recent years, any book presuming to offer representative prices of American collectibles of any kind would be obsolete before the ink dried on the paper. Through the last of the 1980s, however, it is safe to say that a loose, three-tiered market characterizes items ostensibly of southwestern Indian origin. On the low end, pottery proliferates in an eye-dazzling mass of tourist curios, many of them most likely factory-produced and from almost anywhere—the Orient, Europe, Mexico: *caveat emptor*. In the middle market is a commingling, a confusion of convincing imitations and some lovely things indeed. As this book went to press, a visit to the gift shop of the Museum of Northern Arizona revealed these prices on what might be considered standard-quality items of the sizes indicated:

> Ácoma owl, five inches high, $30
> San Juan polychrome jar, nine inches in diameter, $75
> Jemez vase, six inches high, $50
> Hopi flat tile (plaque), seven inches high, $70
> Navajo cooking pot, nine inches high, $35
> Ácoma bowl (miniature), signed by Emma Lewis, $70

More dear items also come and go at this museum shop. For example, at hand on the day I visited were an eighteen-inch-tall Santa Clara jar signed by Mary Singer selling for $1,700; a Hopi bowl signed by Rodina Huma selling for $800; a Cochití storyteller with four children signed by Maxine Toya selling for $600; a five-inch jar with a feather motif signed by the San Ildefonsan potter Blue Corn selling for $700; a ten-inch incised vase by Santa Claran Jody Folwell selling for $2,200; and a six-inch red bowl with a serpent motif signed by María and Santana selling for $2,100.

From this level, the market approaches values of world-class fine art. Collectors of prehistoric and historic items seem willing to pay whatever is required. Consider a 1984 advertisement for a rare Zuni buffalo hunting fetish bowl containing some twenty-five charms, polished stones, and pieces of antler. The bowl was cracked. The price was $6,000. In the same year, a Mimbres bowl was sold by one private Scottsdale collector to another for $80,000. Announcements from Sotheby's and Allards' auctions regularly list successful bids for prehistoric and historic pottery in the multi-thousands of dollars. Since her death, María Martinez's works have appreciated in price: small dishes, $2,000; larger pieces with a discreet signature; $5,000 and more.

An elite cadre of active potters has evolved over the last few years. To make the case with but one example, a miniature, gemlike bowl the size of a golf ball, carved with cameo precision can command $2,000 . . . if done by Joseph Lonewolf.

Needless to say, one who plays this end of the pottery market needs more than a fat checkbook, to wit, a foresighted understanding of an exchange as fickle as commodities futures or mining stocks.

Unfortunately, as in any sector of commerce, the market in southwestern pottery is rife with mild deceptions and outright frauds. Wares of non-Indian manufacture abound. There is nothing illegal about this, and one can fill a freight train with non-Indian curios decorated with designs more or less associated with Indian culture. One step beyond, a goodly amount of Indian pottery today is thrown on a wheel, or is purchased "green," that is, unfired, from factories. Many pieces are fired in a modern ceramics kiln. More serious counterfeiting occurs when an easily forged one-name signature or hallmark is applied to the work of an inferior potter. (María Martinez was especially vulnerable to this phenomenon, due in part to the variety of ways in which she signed her creations, and the various individuals with whom she shared a signature.) The services of an honest and knowledgeable dealer can be beyond price when authenticity is crucial.

CARING FOR POTTERY

Attitude helps. The new owner of an old pot or an old owner of a new pot ought to embrace the view that the vessel is an anthropological treasure, and must be guarded as such. Thus, a record should be written—origin, price, circumstances of purchase, maker—and tucked into the pot.

All pots are not alike. Those with chalky surfaces can be easily disfigured when they come into contact with other materials, much as a ceramic sink is marred by aluminum pans. Highly burnished pottery can suffer scuffing. Thus, pottery should not be put on shelves where it can be carelessly pushed against a wall. There's also danger of thermal cracking, especially with thick, flat blackware placed on windowsills or on mantles; they can be heated unevenly and as a result, shatter. As a general rule, a Smithsonian Institution conservator recommends warm water laced with a mild detergent and a dash of ammonia as a cleaning solution for hard-fired pottery. Antique, unfired, friable, and valuable pieces should be turned over to a professional conservator for cleaning and repair.

Acknowledgements

WHEN I WAS A SLIP OF A KID down on the Gila River Reservation south of Phoenix, I enjoyed the adulation of a square-chested, soft-mouthed springer spaniel, the unlimited use of a broomtailed sorrel mustang, the prideful (and painful) ownership of a single-shot, twelve-gauge goose gun, and the friendship of an almost blind gentleman named Bert Robinson. As superintendent, Bert exercised a wardship over three thousand Pima Indians and a generally unpeopled Sonoran Desert teeming with covey upon covey of seldom-hunted, plump, and plucky Gambel's quail.

I must begin my paragraphs of gratitude with the quail. For, in order to legalize my designs upon the birds, I had to obtain a written hunting permit from the local authority of the Great White Father in Washington, Bert Robinson. "Now, Donald," he would invari-ably begin. "Why will you throw away your good, hard-earned, cotton-hoeing money on

shotgun shells—they must cost a dollar a box, at least—when you could invest in something of real value?" Whereupon he would deftly fetch from his own dark world a jewel-like miniature Pima basket, or a Navajo fetish with anthill garnets, or a Maricopa bowl, blood-red and big as a bucket.

Sensing, not seeing, my grimace, he would relent and scribble a permit. His cataract-beclouded eyes would shine as he wished me luck . . . "and since you seem to be determined, bring home about six nice fat ones for me and Evelyn!" In later life, a medical miracle restored Bert's sight, and he lived to see what he had saved for all of us; I thank God for that.

The quail are long digested, but the osmotic, subliminal wonderment toward the arts of the Indians of the American Southwest lingers.

With no room for a story for each of the following, but in that spirit, I pay my debts and divide none of my errors among: Linda Andrews, June Arbizu, Evelyn Cheromiah, Ned Danson, Cherie Dedera, Lowell English, Hubert Guy, Ken Hedges, Jerry Jacka, Lois Jacka, Tom E. Kirk, Downs Matthews, Susan McDonald, Carl E. Rosnek, Stefani Salkeld, Jack B. Smith, Richard Spivey, Gene Strahan, Betty T. Toulouse, Helen Turner, Tse-pe, Dora Tse-pe, Paul Weaver, Maggie Wilson, and Nancy Winslow.

Selected Readings

Barry, John W. *American Indian Pottery*. Florence, Italy: Books Americana, 1981.

Brody, J. J., Catherine J. Scott, and Steven A. LeBlanc. *Mimbres Pottery, Ancient Art of the American Southwest*. New York: Hudson Hills Press, 1983.

Bunzel, Ruth L. *The Pueblo Potter*. New York: Columbia University Press, 1929. Reprint. New York: Dover Press, 1972.

Canfield, Kenneth. "Pueblo Pottery Reviewed," *The Indian Trader* (January 1978).

Cartwright, Barbara. "The Beauty Collectors," *Arizona Highways Magazine* (May 1974).

Dittert, Alfred E. Jr. and Fred Plog. *Generations in Clay*. Flagstaff, Arizona: Northland Press and The American Federation of Arts, 1980.

Fox, Nancy. "Rose Gonzales," *American Indian Art* 4, no. 2 (1974).

Frank, Larry and Francis H. Harlow. *Historic Pottery of the Pueblo Indians, 1600–1800*. New York: New York Graphic Society, 1974.

Gill, Spencer and Jerry Jacka. *Pottery Treasures*. Portland, Oregon: Graphic Arts Center, 1976.

Goddard, Pliny Earl. *Pottery of the Southwestern Indian*. New York: American Museum of Natural History, 1928. Reprint. Ramona, California: Ballena Press, 1973.

Goldsmith, Laura. "Southwest Pottery is Alive and Well," *The Indian Trader* (May 1981).

Harlow, Francis H. *Historic Indian Pottery*. Santa Fe, New Mexico: Museum of New Mexico Press, 1970.

Houlihan, Patrick T. "Southwest Pottery Today," *Arizona Highways Magazine* (May 1974).

Marriott, Alice. *María The Potter of San Ildefonso*. Norman: University of Oklahoma Press, 1948.

Pilles, Peter J. Jr. and Edward B. Danson. "The Prehistoric Pottery of Arizona," *Arizona Highways Magazine* (February 1984).

Sayles, Gladys and Ted. "The Pottery of Ida Redbird," *Arizona Highways Magazine* (January 1948).

Tanner, Clara. "The Evolution of Southwest Indian Pottery," *Phoenix Magazine* (May 1975).

Underhill, Ruth. *Pueblo Crafts*. Washington, D.C.: United States Department of the Interior, 1944.

Viele, Catherine W. *Voices in the Canyon*. Tucson: University of Arizona Press and Southwest Parks and Monuments Association, 1980.

Ward, Bob. "An Ancient Art is a Thriving Art in New Mexico," *The Indian Trader* (September 1974).

Waugh, Natalie. "Unearthing the First Phoenix," *Arizona Highways Magazine* (February 1984).

Whitefield, Andrew Hunter. *North American Indian Arts and Crafts*. New York: Western Publishing Company, 1970.

Wright, Barton. "Hopi Tiles," *American Indian Art* 2, no. 4 (1944).

Index

Ácoma, 39–42, 80
Adams, Lovena, 27
Adams, Sadie, 27
Aguilar, Rosalie, 63
Allards', 80
American Indian Art Magazine, 79
Ami, Mary, 27
Anasazi, 13, 16–17
Anvil, 13
Apache, 23, 29
Archuleta, Mary, 72
Arizona Highways Magazine, 78
Arizona pottery, 23–33
Armijo, Angie and Rose, 48
Arquero, Juanita, 56
Atencio, Isabel, 65
Avanyu, 62, 67

Baca, Angel, 72
Bahti, Tom, 57

Barrackman, Betty, 32
Basket Makers, 16
Basket Maker sites, 12
Bell, Seferina, 50
Berlant, Tony, 15
Blue Corn, 65, 80
Bread, Vesta, 31
Bunzel, Ruth, 78

Cata, Rose, 65
Cata, Rosita, 73
Chaco, 16
Chalan, Maggie, 56
Chama, Rose, 53
Chapella, Grace, 27
Chapman, Dr. Kenneth, 21, 41, 62
Chaverria, Stella, 72
Cheromiah, Evelyn, 5, 6–7, 43–46
Cheromiah, Josephita, 46
Cheromiah, Lupe, 46

Chino, Carrie, 42
Chino, Grace, 42
Chino, Marie Z., 42
Chino, Rose, 42
Clark Field, 67
Claw, Silas, 29
Claw, Stella, 29
Clay Woman, 38
Cling, Alice, 29
Cochití, 53–57
Cocopah, 23
Coiling, 13
Colorado River Indian Tribes Museum, 79
Comanche, 76
Commission on Indian Affairs, 79
Concha, Alma L., 76
Cordero, Helen, 56
Coronado, 19, 36
Cough, Charlie, 30
Cutler, Nancy, 72

Da, Tony, 2, 63
de Herrera, Rosita, 73
de la Vargas, Diego, 19
Denver Museum of Natural History, 79
Dewakuku, Verla, 27
Duran, Virginia, 2, 75
Dunlap, Carlos, 65
Dunlap, Charlotte, 65

Early southwestern pottery, 11–17
Ebelacker, Virginia, 72
Effigy Vessels, 6
Exposition of Indian Tribal Arts, 21
Exxon Company, USA, 79

Fakes, 81
Fields, Annie, 32
Figurines, 6
First Mesa, 24
Folwell, Jody, 80
Four Corners, 12
Four-Mile, 17
Fragua, Lenora, 53
Fritz, Marcia, 27

Gachupin, Candelaria, 50
Gachupin, Helen, 50
Gachupin, Laura, 53
Gachupin, P. M., 53
Gallup Intertribal Show, 40
Garcia, Delores L., 41
Garcia, Gloria (Goldenrod), 72

Garcia, Jesse, 41
Garcia, Lena, 48
Garcia, Mary L., 41
Gila, 17
Gila River Arts and Crafts Center, 31, 79
Gila River Reservation, 81
Gilpin, Laura, 21
Glenon, Harry, 1–2
Gonzales, Barbara, 63
Gonzales, Juanita, 65
Gonzales, Rose, 3, 63
Gutierrez, Helen, 65
Gutierrez, Lela, 72
Gutierrez, Margaret Lou, 65
Gutierrez, Pula, 72
Gutierrez, Virginia, 59

Hano, 23
Hansen, Anne L., 41
Hardin, Margaret Ann, 37
Harvey, Vina, 27
Havasupai, 22
Hawikuh, 36
Heard Museum, 37, 79
Hewett, Dr. Edgar L., 21
Hillerman, Tony, 78
Hodge, Frederick M., 21
Hohokam, 13, 15–16, 32
Hopi, 23–24, 80
Hopi Arts and Crafts Cooperative, 79
Hopi First Mesa, 20
Hualapai, 23
Huma, James, 27
Huma, Rodina, 80
Huma, Violet, 27

Incised, 6
Indian Arts Center, 22
Indian Arts Fund, 21
Institute of American Indian Art, 2
Institute of American Indian Arts Museum, 79
Isleta, 48

Jemez, 53, 80
Jicarilla Apache, 76
Johnson, Barbara, 31
Juan, Mary, 31

Kachinas, 25
Kavena, Rena, 27
Kayenta, 16
Kemo, Loma, 27
Kidder, Alfred V., 21

Laguna pueblo, 5, 42–46
Lambert, Marjorie, 12
Lawrence, Alma, 31
Legoria, 69–70
Lewis, Carmel, 41
Lewis, Lucy M., 40
Lonewolf, Joseph, 2, 70, 72, 80
Lovato, Anna Maria, 57
Luhan, Mabel Dodge, 21
Lujan, Margaret, 76

Manygoats, Betty, 29
María, the Potter of San Ildefonso, 20
Maricopa, 1, 29–31
Marriott, Alice, 20, 62
Martinez, Adam, 63
Martinez, Anita, 65
Martinez, Julian, 20, 61–63
Martinez, Lupita, 65
Martinez, María, 2, 20, 61–63, 80–81
Medicine Flower, Grace, 72
Medina, Elizabeth, 50
Medina, J. D., 50
Medina, Rafael, 50
Medina, Sofia, 50
Mendelhoff, Cosmos, 19
Mendelhoff, Victor, 19
Mera, Dr. Harry P., 21, 55, 60
Mesa Verde, 16
Mesa Verde National Park, 16
Mimbres, 13–14, 42, 71, 80
Mitchell, Emma L., 41
Mogollon, 13–14
Mohave, 23, 29, 32–33
Montoya, Clara, 65
Montoya, Eudora, 48
Montoya, Tomacita, 73
Mother Earth, 38
Museum of Man at San Diego, 43, 45, 79
Museum of New Mexico, 12
Museum of Northern Arizona, 11, 21, 79

Naha, Helen (Feather Woman), 27
Nambe, 59
Nampeyo, 20, 23
Nampeyo, Fannie, 27
Naranjo, Christina, 72
Naranjo, Flora, 72
Naranjo, Madeline, 72
Naranjo, Teresita, 72
Naranjo, Virginia, 56
National Park Service, 70
Navajo, 27–29, 76, 80

Navajo Arts and Crafts Enterprise, 79
Navasie, Eunice (Fawn), 27
Navasie, Joy, 27
New Mexico pottery, 34–77
Nicolasa, Tia, 61
Nieto, Cecelia M., 53
"Norge", 32
Northern Pueblo Indian Artisans Guide, 79

Oraibi, 39
Ortiz, Serefina, 56

Paddle, 13
Pajarito Plateau, 20, 60
Papago, 23, 32
Paqua (Frogwoman), 27
Paquin, Laura, 48
Pasquia, Bertie, 48
Pavetea, Garnet, 27
Peabody, Henry G., 39
Pecos, 17
Petra, Lois, 72
Picurís, 2, 59, 74–75
Pima, 23, 29–30, 32, 81
Pima baskets, 1–2
Pino, Anita, 65
Pino, Juanita, 50
Pino, Lorencita, 57
Pino, Sorenata, 57
Pojoaque, 59
Popé, 19
Popovi, 63
Prehistoric pottery, 13
Princeton University Art Museum, 41
Pueblo Cultural Center, 79
Pueblo Potter, The, 78
Puyé, 67

Qöyawayma, Al, 27

Ramirez, Virgina, 76
Redbird, Anita, 31
Redbird, Ida, 30–31
Redbird, Malinda, 31
Reserve black-on-white, 14
Robinson, Bert, 81–83
Roller, Tonita, 72
Romero, Marie, 53
Romero, Paula, 76
Romero, Susan (Snowflake), 72
Romero, Terecita, 56
Romero, Virginia T., 76

Salazar, Frances, 72
San Buenaventura Mission, 55
San Felipe, 53–54
San Ildefonso, 20, 59–65, 69
San Juan, 3, 21, 73–74, 80
Sanchez, Angelita, 65
Sanchez, Desideria, 65
Santa Ana, 48–50
Santa Clara, 2, 67–73, 80
Santa Fe, 79
Santana, 2, 63, 80
Santo Domingo, 21, 52–53
School of American Research, 37
Sergeant, Elizabeth Shepley, 21
Shije, Euseba, 50
Shupla, Helen, 72
Shutiva, Ernest and Stella, 41
Sikyatki, 13, 17, 20, 23
Singer, Mary, 80
Sisneros, Dominguita, 73
Smithsonian Institution, 19, 37, 41–42, 46
Sotheby's, 80
Southwest Indian Market, 21
Southwest Museum, 41
Speckled Rock, Rosemary (Apple Blossom), 72
Speckled Rock, Paul, 72
St. Johns polychrome, 14, 17
Stevenson, James, 19
Story Teller, 56
Suazo, Clara, 72
Suazo, Santanita, 72
Suina, Ada, 56
Suina, Frances, 56
Sundust, 31
Sunn, Mabel, 31

Tafoya, Camilio (Sunflower), 2, 70
Tafoya, Juan, 63
Tafoya, Lee, 72
Tafoya, LuAnn, 72
Tafoya, Margaret, 72
Tafoya, Pasqual, 69
Tafoya, Shirley, 72
Tahbo, Alma, 27
Talachy, Joseph, 59
Talachy, Thelma, 59, 72
Tanner, Clara Lee, 21, 36, 60, 63

Taos, 35, 59, 75–76
Tapia, Helen, 72
Tapia, Leonidas, 74
Tapia, Lula, 72
Techniques of pottery making, 5–9
Tenorio, Robert, 53
Tesuque, 57
Tofoya, Vangie, 53
Toledo, Juanita, 53
Toya, Maxine, 53, 80
Trammel, Jennie, 72
Trujillo, Dorothy, 56
Tse-pe (Juan Gonzales), 2, 65
Tse-pe, Dora, 2, 65
Tso, Emmett, 29
Tularosa, 13–14

Underhill, Ruth, 39
University of Arizona, 11
University of Ohio, 70
Ute, 76

Vigil, Albert, 65
Vigil, Charlotte, 65
Vigil, Doug, 65
Vigil, Evelyn, 53
Vigil, Josephine, 65
Vigil, Manuel, 57
Vigil, Minnie, 72
Vigil, Priscilla, 57

Walpi, 23
Wheelwright, Mary C., 21
White, Amelia Elizabeth, 21, 27
White Mountain redware, 15
Williams, Rose, 29
Winslow, Nancy, 44

Yaramata, Elva, 31
Yavapai, 23, 29
Youngblood, Mela (Yellow Mistletoe), 72
Youngblood, Nathan, 72
Youvella, Wallace, 27
Yuma, 23

Zia, 3, 40, 50–51
Zuni, 17, 19, 36–42, 80